50 GEM

Fife

JACK GILLON

AMBERLEY

First published 2022

Amberley Publishing
The Hill, Stroud
Gloucestershire, GL5 4EP

www.amberley-books.com

British Library Cataloguing in Publication Data.
A catalogue record for this book is available from the British Library.

ISBN 978 1 3981 1160 8 (paperback)
ISBN 978 1 3981 1161 5 (ebook)

Typesetting by SJmagic DESIGN SERVICES, India.
Printed in Great Britain.

Contents

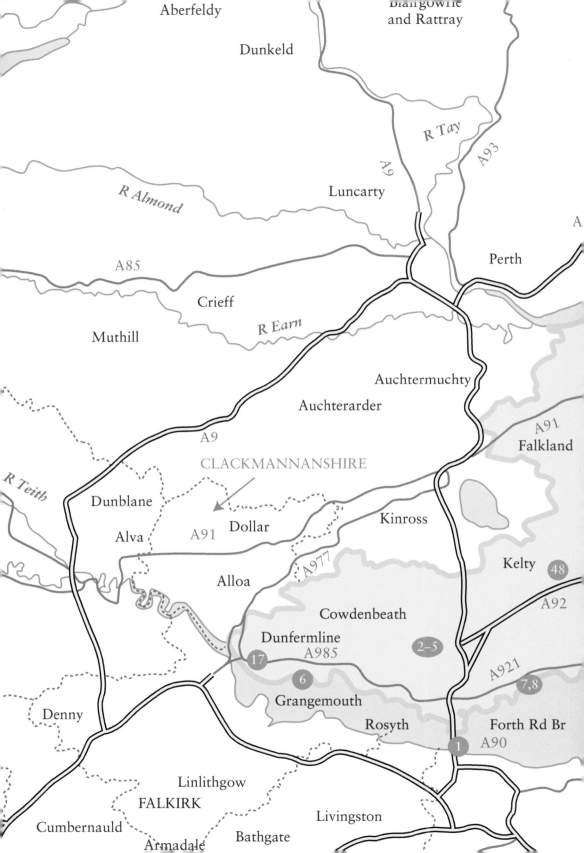

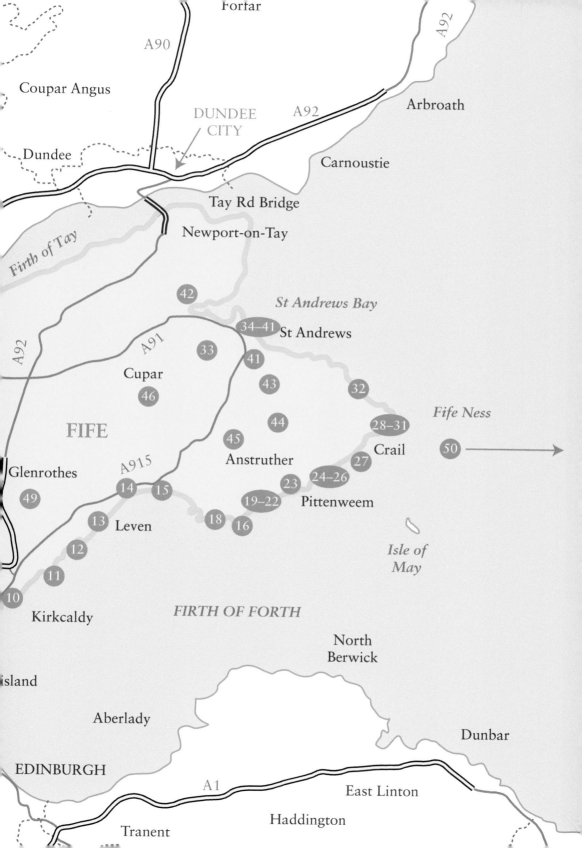

Introduction

Fife is an extensive and important County on the eastern side of Scotland; it is in the form of a peninsula, having the waters of the Firth of Forth on the south, the German Ocean on the east, and on the north the Tay, which separates it from Forfarshire; on the west it is bounded in a very irregular manner by Kinross-shire, Clackmannanshire, and parts of Perthshire. At an early period, the district of Fife, including Kinross-shire, Clackmannanshire, parts of Perthshire, and perhaps part of Stirlingshire, was designated Ross, a term signifying a peninsula, and seems to have been under one jurisdiction. Different events conspired to break up this ample territory into, at least, three distinct counties. From its compact nature and partial independence of support from without, it was the custom to designate it the 'Kingdom of Fife,' a popular phrase still retained. The almost insular position of Fife, between the northern and southern divisions of the Scotland, was of great advantage to the County, by placing it beyond the general sphere of Highland and Border warfare, by which it escaped many of the troubles which long vexed other portions of the country, and was thus enabled, at a much earlier period than other districts, to cultivate the arts of peace. Fife has always occupied a prominent place in the history of Scotland. Though this prominence may be owing, in some degree, to the circumstance that both a Royal residence and the ecclesiastical capital of the Kingdom were in the county, still much is owing to the energy and enterprise which for centuries have characterised the native inhabitants, who have ever proved themselves equally ready to defend or forward the best interests of their country; and in all the contests of the people for their maintenance of their civil and religious liberties, we find the 'men of Fife' at their posts, and distinguishing themselves either as soldiers in the field or councillors in their cabinet.

Westwood's Parochial Directory for the Counties of Fife and Kinross, 1862

Few districts in the country present a greater number of attractions to summer-visitors than that which stretches along the shore of the Forth, from Fifeness to Leven, and which is known as the East Neuk of Fife. The bracing sea-breezes, the clear, blue waves, the flat, sandy beaches, the wild and precipitous cliffs, the remarkable caves, the golfing-links, the fine old churches, the quaint old towns, the ruined castles, the delightful dens, the curious antiquities, the historical associations, the romantic traditions, the beautiful landscape, the magnificent

views, the pleasant drives and walks and rides may all be enjoyed leisurely in this quiet, easy-going corner.

Guide to the East Neuk of Fife, D. Hay Fleming, 1886

The historic county of Fife is a natural peninsula on the east coast of Scotland, bordered by the Firth of Forth and the Firth of Tay. Alongside its three largest settlements of Dunfermline, Kirkcaldy and Glenrothes, it is also home to the ancient city of St Andrews, with its world-famous golf course and university. The often turbulent history of Fife is reflected in its royal palace and castles. Neuk is Scots for nook or corner, and the delightful East Neuk of Fife, with its cluster of picturesque fishing ports and farming communities, is one of the most attractive little nooks in the country. These East Neuk villages have a character which is quite distinct from other parts of Scotland. Many have been relatively unchanged for centuries and, with their irregular streets and local vernacular architecture, reflect the enduring qualities of the area. Fife's cultural and industrial heritage is also celebrated at the Fife Folk Museum, the Anstruther Fisheries Museum, and the Fife Heritage Railway.

50 Gems of Fife explores some of the places that make this part of Scotland special, including natural features, towns and villages, buildings, and places of historical interest. Alongside justly famous attractions, others will be less known, but all have an interesting story to tell.

1. The Forth Bridge

The opening of the Forth Bridge was celebrated yesterday with much éclat. Overnight the Edinburgh hotels were filled with guests who had come from all parts of Britain to take part in the ceremony. Several special trains were run to South Queensferry, and the east end of Princes Street was crowded with coaches. The route along the Queensferry road resembled the road to Epsom on Derby Day. All manner of vehicles made their way westwards, and char-a-bancs could be counted in scores. The spectacle from the bridge was most imposing. The sky was grey and forbidding, but the brightness of the steamers down below, and the exhilaration and excitement of the whole proceedings made everyone careless of the elements.

Dundee Advertiser, 5 March 1890

The Forth Bridge flings its three double steel cantilevers across the water to the Kingdom of Fife. It is the most familiar bridge in the world. To see the Forth Bridge is rather like meeting a popular actress, but with this difference: it exceeds expectations. It is a memorable sight.

In Search of Scotland, H. V. Morton, 1929

The Forth Bridge was inaugurated amidst much ceremony by Albert Edward, Prince of Wales, on 4 March 1890 by the insertion of a gold-plated rivet in the bridge. A

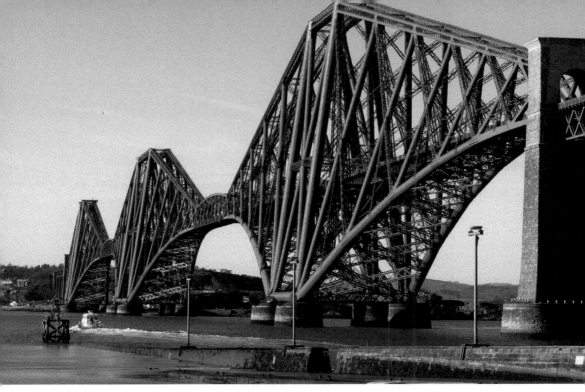

Above: The Forth Bridge.

Below: View from atop the Forth Bridge.

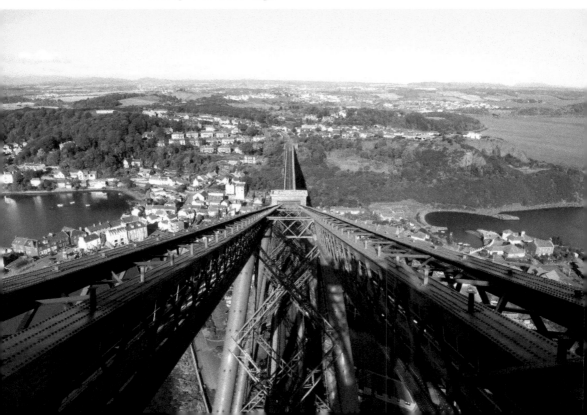

rail bridge across the Forth, linking Lothian and Fife, was first proposed in 1818, although a tunnel was considered by some as a better option. The Forth Bridge Company, which was founded in 1873, appointed Thomas Bouch as the engineer in charge of the contract. However, after Bouch's Tay Bridge collapsed in high winds on 28 December 1879, Bouch's scheme was abandoned – a brick pier from the Bouch design remains near Inchgarvie rock.

Two railway engineers, John Fowler and Benjamin Baker, were awarded the contract for a new design for the bridge. Their proposal was for the world's earliest multi-span cantilever bridge. Work started in 1883 and it took seven years to complete, with up to 4,600 workers employed on the construction. When it was completed, it had the longest bridge span in the world and was the largest steel structure ever built. It ranked as one of the outstanding engineering achievements of the nineteenth century.

A few figures in connection with the construction of the Bridge. Its extreme length, including the approach viaduct, is 2765 yards, one and a fifth of a mile. The weight of steel in it amounts to 51,000 tons, and the extreme height on the steel structure above mean water level is over 370 feet, while the rail level above high water is 156½ feet. About eight million of rivets have been used in the Bridge, 748,670 cubic feet of granite, 64,000 cubic yards of concrete, and forty-two miles of bent plates used in the tubes – about the distance from Edinburgh to Glasgow. These figures will give you some idea of the magnitude of the work. It has probably cost more labour of hand and brain than was ever before expended on any structure. The works were commenced in April 1883, and it is highly to the credit of everyone engaged in the operation that a structure so stupendous and so exceptional in its character should have been completed in seven years.

Dundee Advertiser, 5 March 1890

The bridge still ranks as a masterpiece of engineering and an iconic symbol of Scotland. It was inscribed on UNESCO's list of World Heritage Sites in 2015. The listing noted that the bridge is: 'a masterpiece of creative genius' and 'an extraordinary and impressive milestone in the evolution of bridge design and construction'.

In recent years, the bridge was given a coating of a new paint which is expected to last for decades, and the work of painting the bridge is no longer a never-ending task.

In 2012, a bronze memorial to the seventy-three men who died building the Forth Bridge and to celebrate all the people that have worked on the dangerous job of maintaining the bridge was unveiled. The monument is engraved with the words: 'To the Briggers, past and present, who built, restored and continue to maintain this iconic structure.'

'I waited for the iniquitous ferry which crosses the Forth where a traffic bridge should be' (*In Search of Scotland*, H. V. Morton, 1929).

There had been a ferry at Queensferry since the eleventh century, when Queen Margaret established a service to transport religious pilgrims from Edinburgh to Dunfermline Abbey and St Andrews. In the 1920s and 1930s, the only vehicle crossing was a single passenger and vehicle ferry, but, by 1958, due to increasing demand there were four ferry boats operating 40,000 crossings annually, carrying 1.5 million passengers and 800,000 vehicles. In 1947, the UK government approved

an Act of Parliament to oversee the implementation of a bridge to replace the ferry service. In 1955, an alternative scheme for a tunnel beneath the waters of the Forth was proposed but was soon abandoned. The final construction plan for a road bridge was accepted in February 1958 and work began in September of that year. It was opened by Queen Elizabeth II and the Duke of Edinburgh on 4 September 1964 and the ferry service was discontinued from that date. When it was completed, the bridge was the longest suspension bridge outside the USA and the fourth longest in the world with a total span of 2,828 metres.

In 2017, the Forth Bridge and the Forth Road Bridge were joined by the elegant cable-stayed Queensferry Crossing.

2. Andrew Carnegie Birthplace Museum, Dunfermline

When the benevolence of the late Andrew Carnegie descended on the world in a shower of organs and free libraries the old town of Dunfermline emerged, slightly dazed, from the peace of centuries to grapple with public swimming baths, libraries, public parks, colleges of hygiene, and generally to learn the responsibility of having given birth to a millionaire with the strong homing instinct of the Scot. The cottage, No. 4 Moodie Street, in which Carnegie was born has naturally participated in the local glory and has become swollen to

Andrew Carnegie's birthplace.

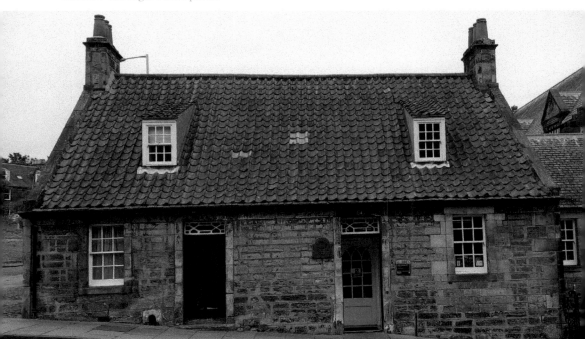

Andrew Carnegie Birthplace Museum.

the proportions of a museum and memorial hall, only a little upstairs room in which he was born, and the adjoining attic have retained their original poverty. When I was there the place was packed. It is one of the famous sights of Scotland.

In Search of Scotland, H. V. Morton, 1929

On 25 November 1835, Andrew Carnegie (1835–1919) was born in a humble eighteenth-century weaver's cottage at Moodie Street, Dunfermline. The family fell on challenging times and, in 1848, emigrated to the United States for the prospect of a better life. After some early struggles in the States, Carnegie went on to make a vast fortune from steel production and other industrial interests. From 1861, he devoted his life to donating the greater part of his wealth to extensive philanthropic activities. Carnegie placed an emphasis on funding libraries. He was particularly generous to his hometown. Dunfermline benefited from the first Carnegie-funded library, which opened in 1883, and numerous other benefactions.

In 1895, the Moodie Street cottage and neighbouring building were purchased by Carnegie's wife, Louise, and were opened to the public in 1908. The adjoining memorial building was also funded by Louise Carnegie as a gift to Carnegie's native town and was formally opened on 28 June 1928. The Carnegie family donated several items to the museum which celebrates the achievements and philanthropy of Carnegie.

3. Pittencrieff Park, Dunfermline

No gift I have made or can ever make can possibly approach that of Pittencrieff Glen.

Andrew Carnegie

Amidst a scene of great popular enthusiasm, formal procession was taken on Saturday afternoon of Pittencrieff Park and Glen, which, with half a million sterling, have been handed over by Mr Andrew Carnegie to a Trust, which has been charged to provide sweetness and light for the toiling masses of the community. Assembling in the Public Park, the demonstrators, who included the members of the Trust, the operatives of the various linen factories, members of the Post Office staff, and different clubs and associations, marched by way of High Street and Bridge Street, and made entry to the Glen at the Pittencrieff lodge gate. Assisted by half-a-dozen brass and pipe bands, the demonstrators made a praiseworthy display. Particularly appropriate was the postmen's picture of Mr Carnegie's birthplace on a gigantic postcard. Underneath the picture were the words, *What though the rooms were wee, kind hearts were dwelling thee.* Along the route of the procession the streets were gaily decorated. Streamers and flags were stretched from house to house across the street at every little distance and the appearance of the buildings all bore striking testimony to the feelings of the people, pictures of Mr Carnegie and the American eagle predominating.

Falkirk Herald and Midland Counties Journal, 25 November 1903

One of the first things which Carnegie did for his native town was to give Pittencrieff as a public park. In this lovely little glen birds are tamer than I have seen them in any town. Children are encouraged to make pets of them, and of the squirrels which come and shake their tails almost under your feet. 'Ye know

In Pittencrieff Park.

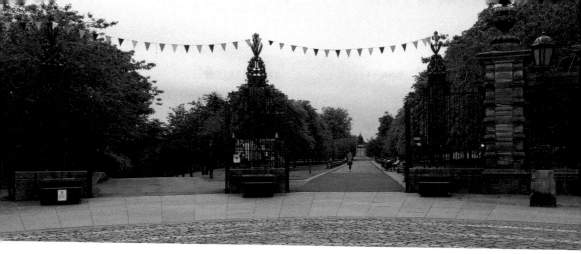

Above: The Louise Carnegie Memorial Gates.

Right: Doocot, Pittencrieff Park.

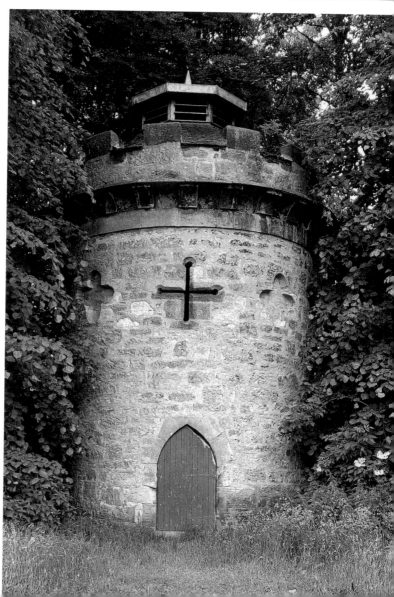

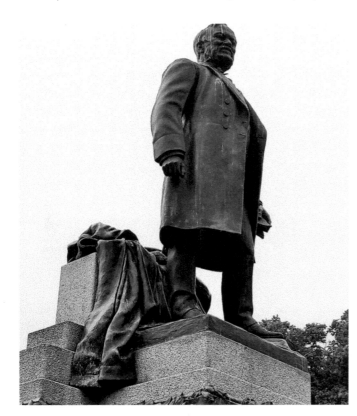

Left: Statue of Andrew Carnegie.

Below: The Tower Bridge.

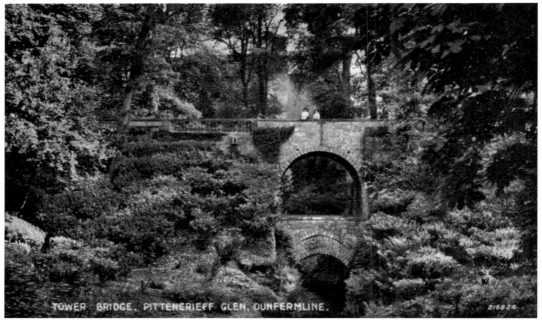

TOWER BRIDGE, PITTENCRIEFF GLEN, DUNFERMLINE. 216824

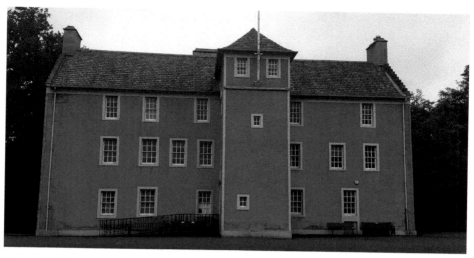

Pittencrieff House.

the reason why he gave us the glen?' asked a man of whom I was discussing the dollars of Dunfermline. 'Ye see, when the late Mr Carnegie was a wee lad, he wasna permitted to enter the park. It was private property. And he never forgot it! When the time came, he gave it to Dunfermline so that no wee child should ever feel locked out of it as he was.'

In Search of Scotland, H. V. Morton, 1929

Pittencrieff Park (The Glen) was gifted to Dunfermline by Andrew Carnegie in 1903 with the aim of providing 'sweetness and light' for the townsfolk. Carnegie's generosity extended to an endowment of three-quarters of a million pounds to set up the Carnegie Dunfermline Trust to maintain the park and benefit the town.

Pittencrieff House stands at the centre of the park. The house was built for Sir Alexander Clerk of Pittencrieff and dates from the early seventeenth century. By 1800, it was owned by the Hunt family. In 1902, Carnegie purchased the Pittencrieff Estate from Colonel James Maitland Hunt.

In 1903, Thomas Mawson and Professor Patrick Geddes submitted plans for the design of the park, which were not fully implemented, but influenced later work. Attractions in the 76 acres of outstanding gardens include the rock garden, the Japanese garden, well-equipped play areas, greenhouses, and woodland walks.

A number of architectural features within the park are of interest: the large bronze statue of Andrew Carnegie, sculpted by Richard Goulden, dating from 1914 and paid for by public subscription; the imposing Louise Carnegie Memorial Gateway dating from 1928 and commemorating Andrew Carnegie's wife; the eighteenth-century circular Gothic dovecot; the art deco music pavilion and cafeteria; and the two bridges over the Tower Burn – the lower segmental pointed-arched bridge, which dates from 1611, built to carry the Dunfermline to Stirling road across the burn, and the upper semicircular-arched bridge, which dates from 1780 and provided more level access to Pittencrieff House, following the diversion of the road. The small formal garden to the west of Pittencrieff House is focused on the Ambition Fountain,

which dates from 1908. The grounds also include the remains of Malcolm Canmore's Tower, an eleventh-century fortress from which Malcolm III (*c.* 1031–93) ruled the Scotland of the time. Pittencrieff House is now a museum and hosts an exhibition about the park and Dunfermline.

4. Dunfermline Palace and Abbey

There are few places in Scotland possessing stronger claims upon the attention of the antiquary, the historian, or even the student of ecclesiastical architecture than the church to which we are now to refer. The venerable remains of a religious establishment which, in splendour and authority, was the rival even of royalty itself; – the mouldering walls of palaces, once the favourite abodes of warlike sovereigns, and the resorts of knightly valour; – the fragments of regal towers, once the dwelling of the saintly Queen Margaret; – and the hallowed spot where, amid a nation's tears, was deposited all that could perish of Bruce, the magnanimous hero, the impersonation at once of genius, valour, and all combine to seize upon the attention, and to invest the Abbey church, the centre of a circle within whose circumference there is so much to excite the imagination, with no ordinary charms for every mind even of the least sensibility.

The Abbey Church, Dunfermline.

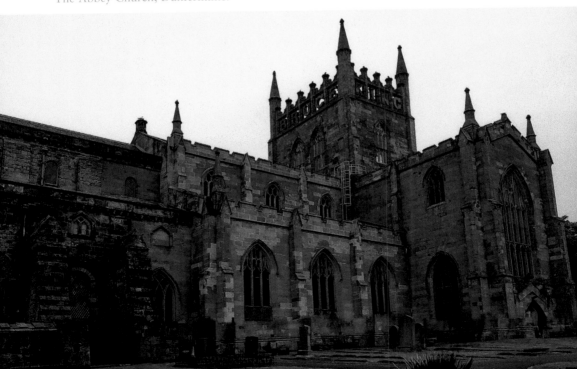

Right: Dunfermline Abbey.

Below: Gatehouse and remains of Dunfermline Palace.

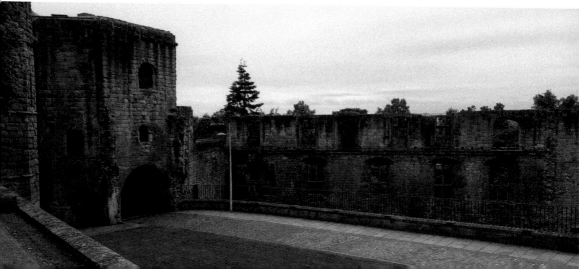

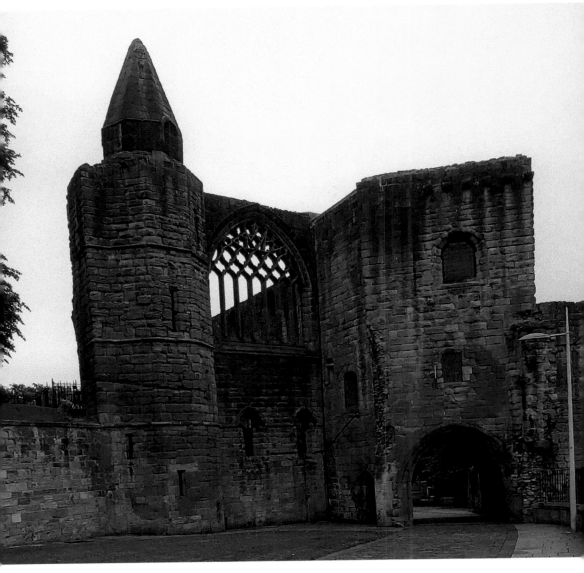

The Gatehouse, Dunfermline Palace.

The architecture of the ancient portion of the Abbey church presents features of considerable interest. It is what was originally the nave, the choir, having been destroyed. It seems to be not improbable that the original style in which the whole edifice was built was the Norman. As respects the new church now built, as before mentioned, on the site of the ancient choir, the following are the remarks of the author of the Statistical Account. After alluding to other buildings in Dunfermline, he observes, 'the largest, most splendid, and interesting ecclesiastical edifice of modern date is the Abbey church.' It was

begun in March 1818 and completed in September 1821. It immediately adjoins the old church on the east, the latter being now a porch or vestibule to it. It is of light ornate Gothic architecture, with tall handsome windows, and having a fine square tower near the east end 100 feet high. On the summit of this tower, instead of a balustrade of the same architecture as the rest of the building, there are the four words, 'King Robert the Bruce,' on the four sides respectively, in capital letters of open hewn work, four feet in height, which can be easily read at a considerable distance. These are surmounted by royal crowns, and each corner is ornamented with a lofty pinnacle. This decoration is intended to designate the place of sepulture of our great patriot King, whose ashes repose beneath; but the taste and architectural effect of it are questioned by many. The interior of the church is much and universally admired, for the simplicity, chasteness, and elegance of its form and ornament.

The Kirk and the Manse, Revd Robert Fraser, 1866

Malcolm III, the King of Scotland from 1058 to 1093, made Dunfermline the capital of the country and it was the power base of Scottish royalty for centuries. In around 1072, Queen Margaret, the wife of Malcolm III, established a Benedictine Priory dedicated to the Holy Trinity in Dunfermline. In 1128, Queen Margaret's son, David I, transformed it into an abbey and built a magnificent new church. In 1304, the abbey buildings were partly destroyed by Edward I during the Wars of Independence; the reconstruction was funded by Robert the Bruce. The abbey was dissolved in 1560, following the Protestant Reformation. The nave of the Abbey Church was converted into a parish church and the choir fell into ruin. The New Abbey Parish Church, with its distinctive *KING ROBERT THE BRUCE* lettering, dates from 1821 and was built on the site of the choir and transepts of the former Abbey Church. Malcolm Canmore, Robert the Bruce and other Scottish monarchs are interred at the Abbey Church. Robert the Bruce's heart was taken on crusade before being buried at Melrose Abbey. Queen Margaret (1045–93) was canonised in 1250 and her remains moved to a shrine at the east of the church. Following the Union of the Crowns in 1603, the monarchy moved to London and Dunfermline lost its royal connections. By 1708, the palace at Dunfermline, which had been home to generations of Scottish royalty, was in a ruinous condition and the south wall is all that remains of the once splendid building.

5. Abbot House, Maygate and Abbot Street, Dunfermline

The Abbot's house is near the centre of the town, and, though somewhat modernised, is still quaint and picturesque. It is a many-gabled structure, long and irregular in its plan. Over the main entrance is placed an 'advice stane', on which is carved the following admonition:

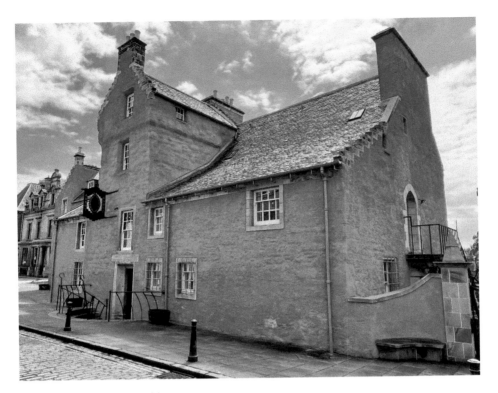

Above and below: The Abbot House.

'*Sen.Vord.Is.Thrall.And.Thoght.Is.Fre/Keip.Veill.Thy.Tonge.I.Coinsell. Thee*' an advice that is always in order, and which, being rendered into modern English reads: 'Since word is thrall, and thought is free/Keep well thy tongue, I counsel thee'. It is recorded that this quaint inscription was place there by Robert Pitcairn, Archdeacon of St Andrews, and secretary to James VI, as a caution to the inhabitants against talking too much. This building, according to Dr Henderson, in his 'Annals of Dunfermline,' dates back to the thirteenth century, and was used as a convent of Blackfriars.

The Canadian Magazine, 1894

The Abbot House dates from the mid-fifteenth century and is the oldest secular building in Dunfermline. It is known locally as the 'Pink Hoose' due to its distinctive coral-pink harled exterior. It was originally built as a substantial residential townhouse (there is also evidence that the ground floor was used as a workshop), which was rebuilt and extended in the sixteenth and seventeenth centuries. It has only been known as the Abbot House since the nineteenth century and, although there is no unambiguous evidence to indicate that it was used by the Abbot of Dunfermline, it would have been within the grounds of the monastery. Its stone construction prevented its loss in the major fire in Dunfermline on 25 May 1624. Highlights of the Abbot House include the beautiful medieval walled garden and a sixteenth-century fresco in one of the principal rooms.

The status of the building declined from the eighteenth century, and it was converted to a multiple-ownership tenement during the nineteenth century. It was purchased by the Carnegie Dunfermline Trust in the early part of the twentieth century and functioned as a school. In 1995, it opened as a heritage centre, which closed in 2015 due to funding issues. In 2019, grant funding allowed the start of renovation work on the building which will ensure that the Abbot House remains a significant heritage asset to Dunfermline for many years to come.

6. Culross

Culross, with its narrow cobbled streets, picturesque red-pantiled cottages, grander merchants' houses and burgh buildings is a unique place which appears frozen in an earlier century. In the sixth century, Culross was a religious centre, and the monks mined the plentiful coal deposits around the Forth. In 1575, Sir George Bruce (1550–1625) was granted the lease of the local collieries. Bruce developed several innovative mining techniques and Culross prospered until a storm in 1625 seriously damaged the mine workings. Bruce died shortly after, the economy of Culross declined, and the village was little changed over the centuries. From 1932, the National Trust for Scotland commenced a programme of restoration in which hundreds of buildings were refurbished in traditional style. Some of the highlights of a tour around the village include: the seventeenth-century Town House, the Study (1610) with its gabled roof and corbelling, the Mercat Cross, Culross Abbey, and Bishop Leighton's House.

In Culross.

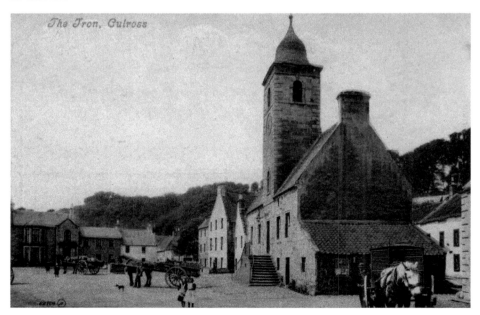

The Tron, Culross.

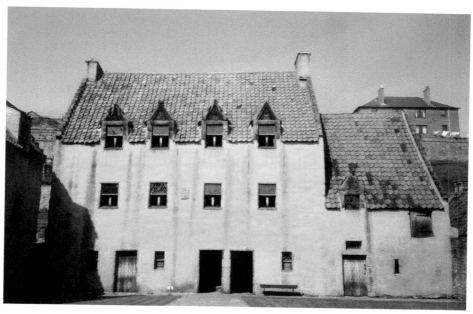

Culross Palace.

Culross Palace dates from the early seventeenth century and was built as the home of Sir George Bruce. Palace is something of a misnomer and the original title deeds refer to it as the Great Lodging. With its courtyard, stable block and walled garden, it would have been the grandest residence in the village. It is an outstanding example of a mansion townhouse with associated buildings and gardens. The interior features an array of splendid rooms, including the particularly notable painted chamber with its original seventeenth-century painted ceiling which is a prime example of Scottish Renaissance decoration.

7. Aberdour Castle

Aberdour Castle, a ruinous mansion of the Earls of Morton and Barons Aberdour, held by their ancestors since 1351, earlier by Viponts and by Mortimers. Its oldest portion, a massive keep tower, chiefly of rough rubble work, with dressed quoins and windows; additions, bearing date 1632, and highly finished, mark the transition from Gothic forms to the unbroken lines of Italian composition that took place during the seventeenth century. Accidentally burned 150 years since, this splendid and extensive pile has formed a quarry to the entire neighbourhood.

Ordnance Gazetteer of Scotland, 1882

The core of the castle was a two-storey hall house built for the De Mortimer family in around 1200. This was enlarged and added to over the centuries by the Earls of Morton. One of the highlights of the castle is the early seventeenth-century painted ceiling in the east range with its colourful array of fruits, flowers and cherubs.

The splendid gardens that surround the castle are recorded as early as 1540 and are amongst the earliest in the country. The elegant circular beehive dovecot to the south of the castle contains around 600 nesting boxes and is first recorded in 1540.

The property is now in the care of Historic Environment Scotland.

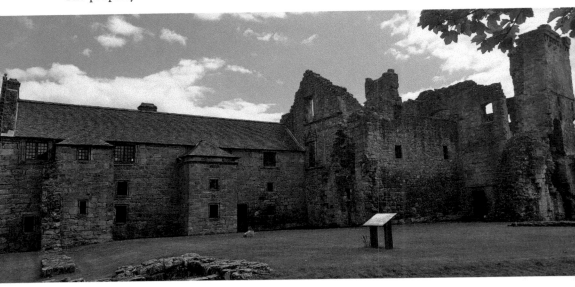

Aberdour Castle.

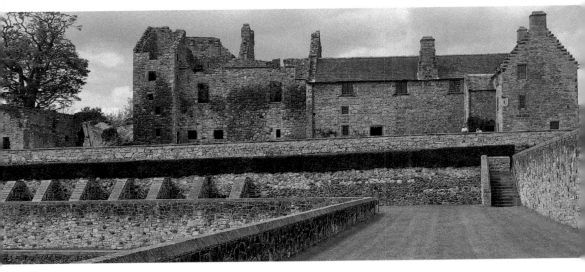

Aberdour Castle from the garden.

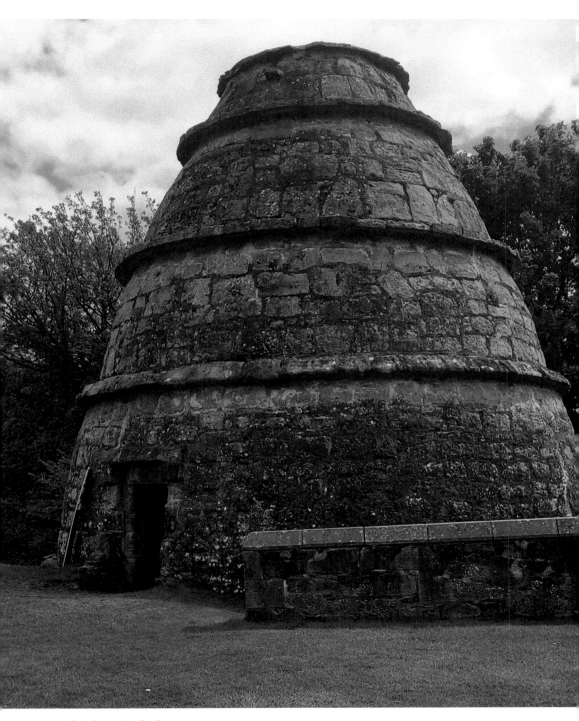

Aberdour Castle dovecote.

8. Silver Sands and Hawkcraig Point, Aberdour

'And do you know, mamma,' said Alfred, 'I was told that there is such a splendid bed of oysters in the White Sands Bay.' 'Call it the Silver Sands, Alfred,' cried Nora, 'it is such a pretty name.' Yes, you little fairy, it is the best name, for last night, in the moonlight, the bay viewed from the woods was perfectly lovely. The waves came crisping in on the pure white beach like molten silver. The dark

Above and below: Silver Sands, Aberdour.

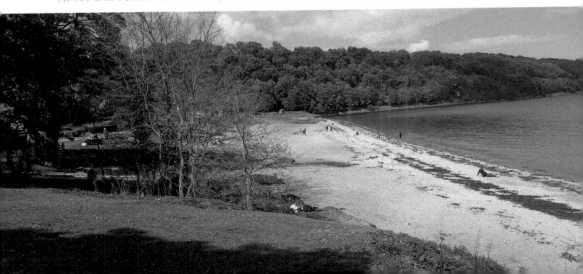

shadows among the depths of the solemn woods were reflected away down in the water; out at sea several ships, and a number of boats glided like phantoms across the track of moonlight; while above all, the queenly moon sailed softly through the vast depth of the heavens.

The Beauties and Antiquities of Aberdour, Mary SL White, 1869

The Silver Sands at Aberdour, with its sandy bay fringed by woodland, excellent amenities and views over the Forth to Inchmickery and Inchcolm, is one of the most popular seaside spots on the Fife coast.

Half ower, half ower to Aberdour,
'Tis fifty fathoms deep,
And there lies gude Sir Patrick Spens,
Wi' the Scots lords at his feet.

Hawkcraig Point, Aberdour.

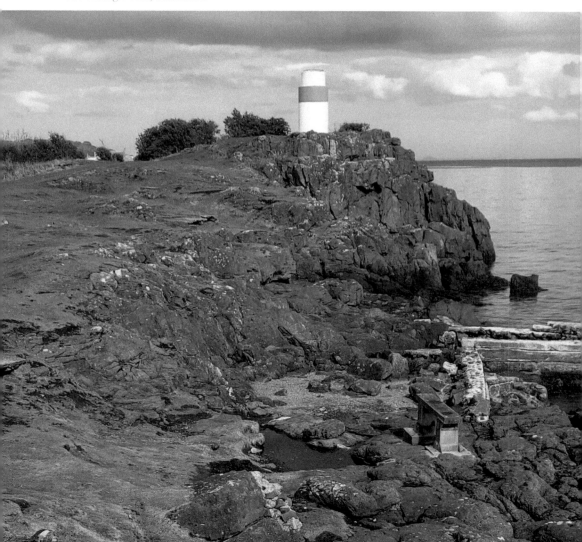

It is well known that Aberdour is mentioned in the last verse of popular versions of the ballad Sir Patrick Spens. However, there is a theory, supported by the eminent literary and intellectual figure Dr Robert Chambers (1802–71), that the strand mentioned in the third verse of the ballad is the Silver Sands at Aberdour.

> The King has written a braid letter,
> And sealed it with his hand;
> And sent it to Sir Patrick Spens,
> Was walking on the strand.

The rocky headland at Hawkcraig Point, a short walk from the beach, offers panoramic views of the Firth of Forth. A number of relics of the First World War Admiralty Experimental Station remain at Hawkcraig Point. Between 1915 and 1918, the sonar experimental station at Hawkcraig made significant technological advances in the development of hydrophones (underwater microphone receivers) for the detection of submarines, which were a major threat to merchant shipping.

9. Ravenscraig Castle, Kirkcaldy

The remains of Ravenscraig Castle form one of the chief objects of attraction to the tourist, who may be skirting the northern shores of the Firth of Forth. He will see 'Lang Kirkaldy'; and to the eastward of this the bold, commanding ruins of Kirkaldy Castle, situated on a towering rock, overlooking the wild Norland Seas.
The History and Legends of Old Castles and Abbeys, John Dicks, 1850

Ravenscraig Castle stands on a high rocky cliff which drops steeply to a shingle beach and provides a naturally defensive position. It is within the grounds of the extensive Ravenscraig Park between Kirkcaldy and Dysart.

Ravenscraig Castle.

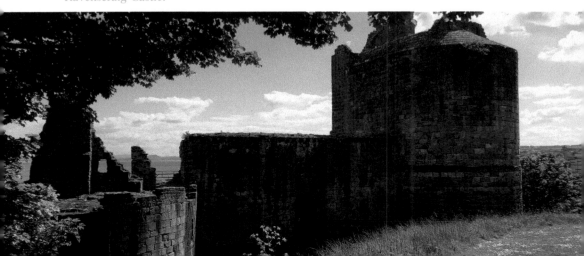

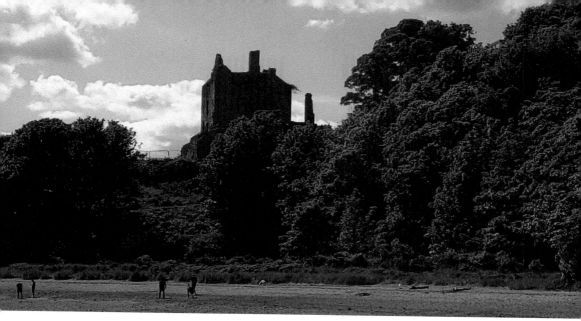

Ravenscraig Castle from the beach.

The castle was originally intended as a royal palace for Mary of Gueldres (1434/1435–63), the wife of King James II (1430–60), and work commenced on its construction in 1460. The castle was one of the first to be constructed to withstand artillery fire with massively thick walls. This was tested in 1650 when it was attacked by Cromwell's forces.

James II was an enthusiast for the artillery of the time and ironically was killed by an exploding cannon at the Siege of Roxburgh Castle in August 1460. Work on the castle was continued by the Queen until her death in 1463. The castle passed to the Sinclair family, the Earls of Caithness, who completed its construction. The castle was abandoned in 1750 and the estate remained in the ownership of the Sinclair family until 1896, when it was purchased by a local linoleum magnate. In 1929, the estate and the castle was gifted to Kirkcaldy. The castle is now in the guardianship of Historic Environment Scotland.

10. Feuars Arms, Commercial Street and Bogies Wynd, Kirkcaldy

The period 1880–1910 is generally recognised as the golden age of pub design, when the earlier basic taverns were swept away. New licensing regulations required any establishment selling alcohol to be licensed and the authorities encouraged open

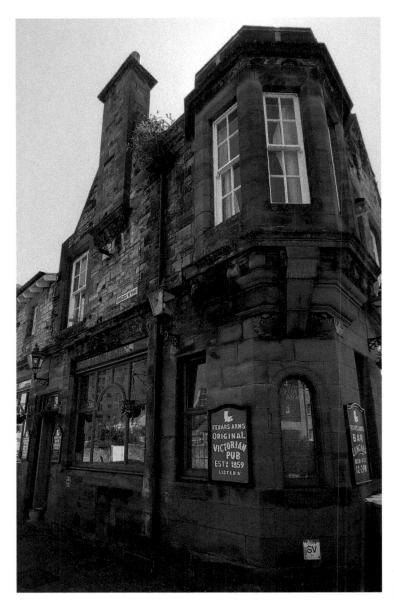

The Feuars
Arms frontage.

planning in pubs which, combined with the addition of island bars, enabled staff to closely supervise customers. The evils of drink were also associated with many social problems. Pub owners responded by investing in extremely grand premises that moved the establishments upmarket from the dingy drinking dens of earlier years.

These new pubs were ornamented with an abundance of spectacular decoration to attract customers into their shining interiors: elaborate facades; brightly coloured tiles, which had the added advantage of being durable and easy to clean; richly carved wooden panelling; decorative glass; advertising mirrors, known as showcards;

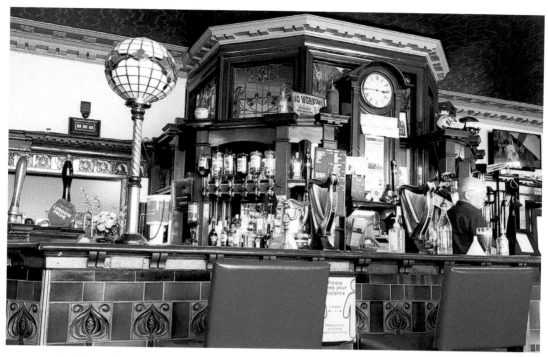

The Feuars Arms bar.

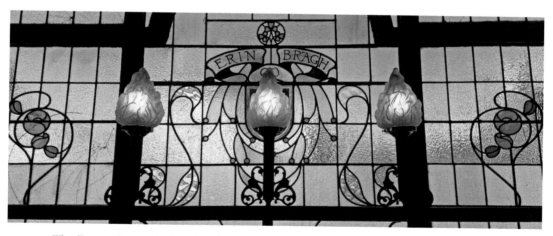

The Feuars Arms window detail.

elaborate gantries (from an old Scottish word which meant a frame for holding barrels) for dispensing spirits, which are much more common in Scotland than in England due to the Scots' traditional preference for drinking whisky rather than beer; and sumptuous ornate plasterwork. They glistened at night offering a warm and welcome escape from the Scottish weather and often inferior housing conditions of the time.

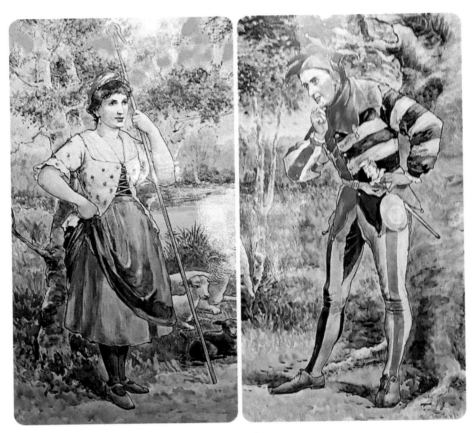

Feuars Arms Shepherdess and Jester tiled murals.

Pubs operate in an aggressively competitive market and are subject to the vicissitudes of changing taste and fashions. From the 1970s, commercial pressures have resulted in many pubs being renovated and their historic interiors removed – often replaced with reproduction fittings. Those that remain are of exceptional value and that is particularly the case with Kirkcaldy's Feuars Arms.

The Feuars Arms, which is in the Pathhead area of Kirkcaldy, was converted from a flour mill to a pub in 1859. In 1890, the exterior was rebuilt in a Jacobean style and the interior was remodelled with fashionable art nouveau features in 1902.

The pub retains its exceptional interior fittings. Some of the highlights include: the stained-glass windows, which are embellished with stylised flowers and the heraldic devices of Scotland, England, and Ireland; the U-shaped bar, which is fronted with decorative art nouveau tiles and surmounted by ornate glass lanterns; and the tiled walls, which include two Doulton panels depicting a jester and a shepherdess. There is even an original glass cistern in the men's toilet facilities.

Pathhead was an independent village until its amalgamation with Kirkcaldy in 1876. The pub takes its name from the Pathhead Society of Feuars, an organisation of local landowners which had a significant role in managing the village until the amalgamation.

11. West Wemyss, Tolbooth

West Wemyss, distant nearly two miles from Dysart, is a burgh of barony, and is governed by two bailies, a treasurer, and council. Very little back history belongs to this village. In the grand salt-pan time, a little stroke of business in that line was done at West Wemyss. It has always been inhabited by a community of colliers, and the appearance of the village smacks of the circumstance. Although in closer contiguity to the Castle above than East Wemyss, the grimy burgh of barony is not the holiday pride of the proprietor of the parish. No; West Wemyss is useful, East Wemyss ornamental. There is

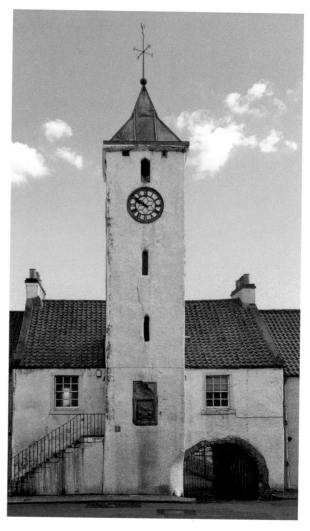

Tolbooth, West Wemyss.

no noticeable feature about West Wemyss, oh, reader, which need detain us. There is a small harbour, indeed, where schooners and sloops load coals. There is also a main street of unequal proportions, and independent as to pavement. From it rises a very little way into heaven a most comical steeple, surmounting the tolbooth of the burgh. The steeple and the tolbooth are in extremely dingy circumstances, almost bordering on the picturesque.

The Fife Coast from Queensferry to Fifeness, Henry Farnie, 1860

Visitors and villagers at West Wemyss held their annual sing-song and dance from midnight into the wee sma' oors of Saturday. The open-air midnight festival has become an annual feature. The crowd gathered round the steps of the ancient Tolbooth and took part in community singing and dancing.

The Courier and Advertiser, 25 July 1958

West Wemyss developed as a centre for salt panning and its harbour, which dates from 1621, developed for the export of salt and coal from mines in the area. The loss of the village's industrial base in the second half of the twentieth century and a decline in the area's prosperity has been reversed in recent years by a programme of investment. It is now an attractive conservation village.

The tolbooth with its high clock tower is a landmark feature in West Wemyss. A tollbooth in West Wemyss is first mentioned in 1586, although its exact location is unknown. The present tolbooth dates from the early eighteenth century and was built for David, 3rd Earl of Wemyss (1705–20). It would have been the administrative hub of the town serving as the centre of local administration with a jail and council chambers. The inscribed panel on the frontage depicts the arms and initials of the Earl of Wemyss, and an upper section, which is now lost, is said to have read: *This Fabric was Built by Earl David for the Cribbing of Vice and Service to Crown.* The tower was converted from a pigeon loft to a clock tower in 1901 and, in 1974, the slate roof was replaced with a fibreglass frame covered with copper.

12. The Wemyss Caves

The name Wemyss is derived from the Celtic word *Wamh,* meaning caves and that the name is altogether appropriate may be seen from the number of caves in the rocks on the foreshore. The largest is situated between Wemyss Castle and East Wemyss; and tradition asserts that, in this cave, was manufactured the first glass made in Scotland. It yet retains the name of the Glass Cave. The Court Cave, situated close to East Wemyss, extends about 200 feet in a north-westerly direction. Its breadth is very irregular, but at no point is it more than 60 feet; and in height it varies from 20 to 30 feet. This cave has been rendered famous by a tradition that King James V, in one of his frolicsome moods, here fell in with an encampment of gypsies. He joined the company, and a graphic story is told of his adventures on the occasion.

Westwood's Parochial Directory for the Counties of Fife and Kinross, 1862

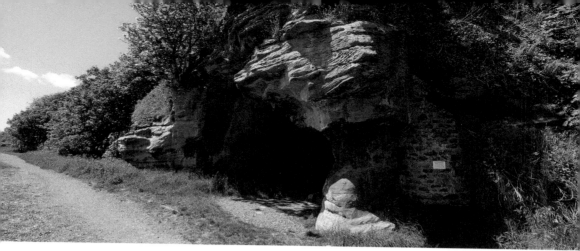

Above: Wemyss Caves.

Right: Macduff's Castle.

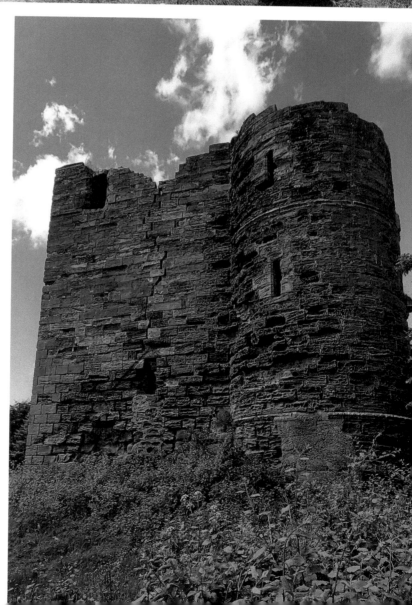

The sea caves at East Wemyss contain an important collection of Bronze Age, Pictish and early Christian carvings. The unique animal and abstract Pictish examples, which are estimated to date back 1,500 years, are of national importance.

There were once twelve caves, however, coastal erosion, structural instability and mining activity have reduced the number to four. The Court Cave takes its name from its use in the Middle Ages as a baronial court and contains a number of ancient carvings. The Doo Cave includes inscribed symbols and was historically used as a dovecote – nesting boxes remain carved into the walls. The Well Cave once included a spring, St Margaret's Well, which was believed to have healing properties. Jonathan's Cave takes its name from a man called Jonathon who lived in the cave at the end of the eighteenth century. Jonathon's Cave contains the most extensive collection of Pictish carvings and early Christian crosses. Between 1610 and 1730, the Glass Cave was large enough to include a glass factory which was one of the earliest in Scotland. The cave collapsed when the Michael Colliery was sunk east of the cave.

The Save the Wemyss Ancient Caves Society aims to protect the caves and carvings. The society operates a visitor centre and museum which interprets the story of the caves and is a base for guided tours.

The remains of Macduff's Castle stand on the cliffs above the caves.

13. Fife Heritage Railway, Kirkland Sidings, Leven

The Fife Heritage Railway was established at Kirkland Sidings in Leven in 2003. The site displays an impressive array of locomotives and rolling stock associated with Fife. The collection is based on items from the Lochty Private Railway, which closed in 1992. The Kingdom of Fife Railway Preservation Society took over the Lochty

Fife Heritage Railway.

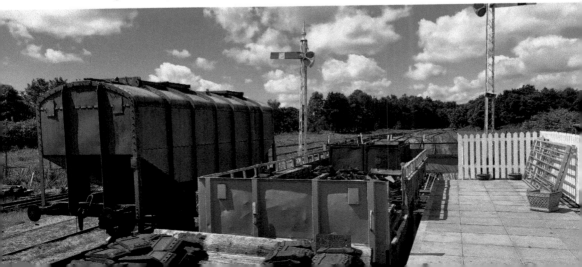

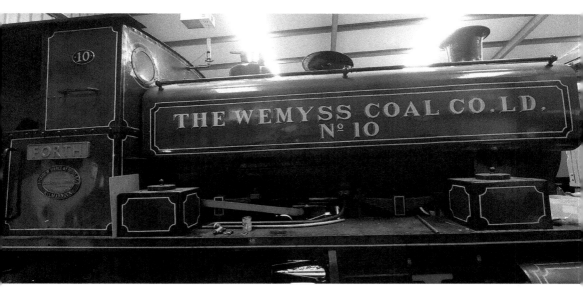

Fife Heritage Railway Wemyss Coal Company locomotive.

stock and it was stored at the former Methil Power Station until it was moved to the 41-acre site at Kirkland Sidings in 2001.

The restoration workshops and railway line are run by enthusiastic volunteers, and visitors are welcome to drop in at suitable times or on Open Days when trips on the track are available.

14. Standing Stones, Lundin Links

The Standing Stones of Lundin are very conspicuous objects, nearly half-a-mile further west than the village. The most massive of the three is fifteen feet high, fully two feet thick, and its greatest breadth is about six and a-half feet. The other two are rather taller, but are not so substantial. They are supposed to be as deep in the ground as they are above it. Whether that is quite the case or not, it is marvellous how such huge blocks of stone could be brought here and erected at a remote age, when there were no engineering appliances. The visible portion of the largest must be fully ten tons in weight. There are also fragments of a fourth, which seems to have been of equal magnitude with the other three.
Guide to the East Neuk of Fife, D. Hay Fleming, 1886

Lundin Links was originally three villages – Lundin Mill, Newton of Lundin Mill and Emsdorf. The town takes its name from the Lundin family, who were granted

Standing Stones, Lundin Links.

land here in the twelfth century, and as the name suggests milling was the principal activity from the seventeenth century. The town developed as a nineteenth-century suburban extension of Lower Largo for the accommodation of holidaymakers. The Lundin Golf Club was founded in 1868. In 1908, a new course was laid out by the renowned golf course designer James Braid on part of the original course and on the nine-hole Lundin Ladies' Golf Club – the ladies were displaced to a new course designed by James Braid in the Standing Stones Park. The first ball on the new course was struck on 29 November 1909. The Lundin Ladies' Club was established in 1891 and is one of the oldest women's golf courses in the world.

The group of three tall, irregularly shaped ancient standing stones on the second fairway of the ladies' course at Lundin Links are the most impressive examples in Fife. There were four stones until the end of the eighteenth century and it is conjectured that they are the remains of a second millennium BC stone circle. It is advisable to ask permission at the starter's box before visiting the stones.

15. Lower Largo – Alexander Selkirk Statue

The Unveiling of the Statue of Robinson Crusoe at Largo. Yesterday was an eventful day in the annals of the villages and surrounding districts of Largo and Lundin Mill – the occasion being the unveiling of a statue to the immortal hero Robinson Crusoe. It is not so generally known that the fishing village of Largo lays claim to being the birthplace of Alexander Selkirk, the prototype of Daniel Defoe's Robinson Crusoe. The inhabitants of the village were early astir and appeared to manifest great interest in the important event. The village was gaily decorated, flags and banners being hung from the various house windows. At the Robison Crusoe Hotel a triumphal arch was erected, composed of evergreens, flags, &c, with the words above, 'Welcome here to the Earl and Countess of Aberdeen,' and on the other side were the words, 'Will ye no come back again.' At Drummochie another arch was erected with the motto, 'Let Largo Flourish.' Opposite the statue was another with the words, 'Robinson Crusoe, we see good and great at last.' Altogether the village presented an imposing and attractive appearance.

In the forenoon a grand trades procession was formed. It was headed by James Elder, carter, who was mounted on horseback, and dressed up with goat skins as representing Robinson Crusoe. He was accompanied by his faithful servant, Friday (John Martin, Jun). The Largo band followed. The female workers of Cardy Mill came next. They carried a large banner representing the lion and the unicorn. A model of a net machine, with a girl at work followed. The fishermen followed, headed by a lorry on which was a fishing boat named Robinson Crusoe. They carried banners with the inscription, "We are on the right tack; you

Lower Largo Harbour.

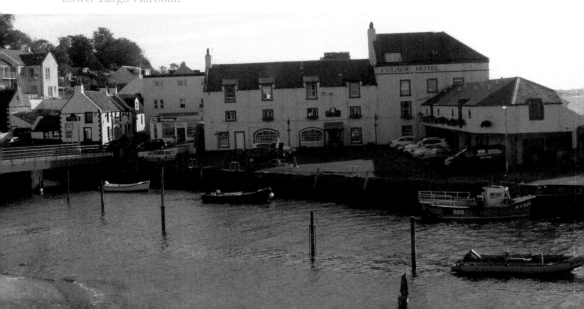

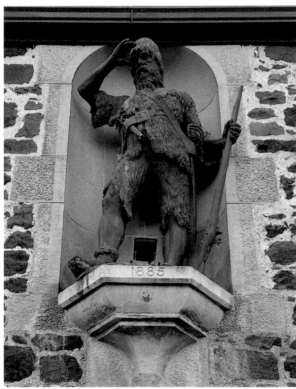

Left: Crusoe statue, Lower Largo.

Below: Crusoe House, Lower Largo.

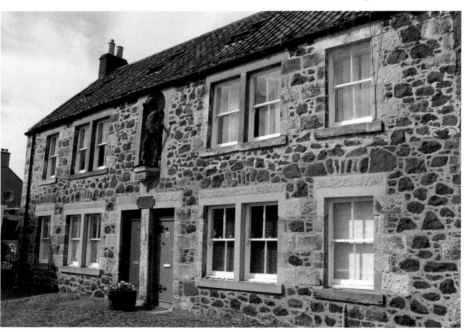

should have given in; make ready your lifeboats and learn to swim' and 'Weel may the boatie row." The bakers presented a credible appearance in their white aprons and red caps. They carried various implements belonging to their trade, and on a board were the words, "We're here today, workmen of the dough, to honour the memory of Robinson Crusoe." The butchers had a cart and were busily engaged at a mincing machine. The joiners had a neat model of the house in which Robison Crusoe was said to have been born. Several milk floats adorned with evergreens brought up the rear. Altogether the procession was most successful from first to last. The procession marched through the villages of Lower Largo, Upper Largo, Kirkton, and Lundin Mill, and back to the statue.

Fife Free Press, 12 December 1885

There has been a haven for boats at Lower Largo, where the Keil Burn flows into the Forth, since at least the sixteenth century. The pier was built in around 1770 and was extended in the early nineteenth century, although it never had an enclosed harbour like most other East Neuk fishing villages. The harbour once served a herring fleet of nearly forty fishing boats and was important for the export of local agricultural produce and coal. The harbour is overlooked by the three-storey nineteenth-century former grain warehouse building which was first occupied as the Harbour Inn in 1828 and later became the Crusoe Hotel in honour of Alexander Selkirk.

Alexander Selkirk was born in Lower Largo in 1676. His father was John Selcraig, a prosperous shoemaker. Alexander was a wilful young man and at the age of

Alexander Selkirk's birthplace.

thirteen he was part of a mob that attacked the local Episcopal minister. Six years later he was cautioned for misbehaving in the church and went off to sea. In 1701, back in Lower Largo again, he attacked his brother and soon after this he went back to sea. In 1704, Selkirk was sailing master of the privateering ship the *Cinque Ports*. Selkirk had no confidence in the seaworthiness of the ship or the captain, arguments broke out and Selkirk decided that he would rather be left on Más a Tierra, one of the Juan Fernández Islands, in the Pacific Ocean 670 km (420 miles) off the coast of Chile, than continue in a dangerously leaky ship. Selkirk was marooned on the island for four years and four months. He was remarkably self-reliant: building huts; catching seals, shellfish and goats for food; fashioning clothes from goat skins; and training feral cats to protect him from voracious rats while he was sleeping. On 31 January 1709, he was eventually rescued by a passing ship.

Alexander Selkirk returned to Lower Largo in the spring of 1712. While in the village, he is said to have shunned human company and lived in a cave in the garden of the family home. In 1717 he eloped to London with a local woman. Selkirk continued a seafaring life and was buried at sea off the coast of West Africa in 1721. The story of his life on the desert island was widely reported and inspired Daniel Defoe's fictional Robinson Crusoe in the novel of 1719.

Selkirk's house in Lower Largo was demolished in 1865 and replaced with a two-storey tenement. On 11 December 1885, a bronze statue of Selkirk in the guise of Robinson Crusoe was unveiled by the Earl of Aberdeen amongst much ceremony in a niche of the new building on the site of his birth in Lower Largo. The statue depicts Crusoe in a goat skin coat with tattered breeches armed to the teeth with a musket, pistol and claymore and shading his eyes with his right hand to catch a glimpse of a passing boat. It was noted that 'it was spiritedly designed and perfectly executed and that it looked like an old friend to all who had read the romance of his voyage'. It was Sculpted by T. Stuart Burnett and paid for by David Gillies, a local net manufacturer.

In 1966, the Chilean government renamed the island on which Selkirk was marooned Robinson Crusoe Island, with another island, Isla Más Afuera, renamed Alejandro Selkirk Island. A signpost at the harbour in Lower Largo points to Juan Fernández Islands, some 7,500 miles distant, where Selkirk was a castaway.

16. Elie Ness Lighthouse and the Lady's Tower

The 36-foot-high Elie Ness Lighthouse first officially shone a light to assist navigation on the Forth on 1 October 1908. The engineer was David Alan Stevenson, grandson of the famed lighthouse engineer Robert Stevenson and cousin of Robert Louis Stevenson. The light flashes every six seconds and is visible for 18 nautical miles. In the early part of the twentieth century pressure was building on the Commissioners of Northern Lighthouses for the erection of a lighthouse on Elie Ness. Master mariners of all nationalities argued that in severe weather, when off Elie Ness, they

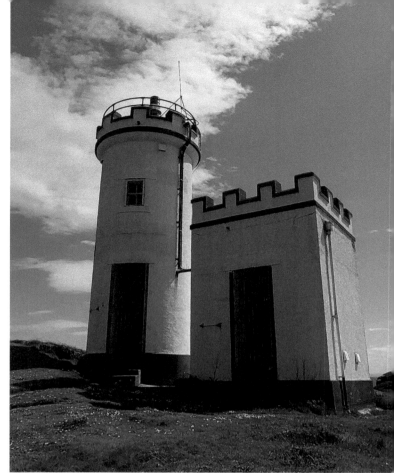

Right: Elie Ness Lighthouse.

Below: The Lady's Tower.

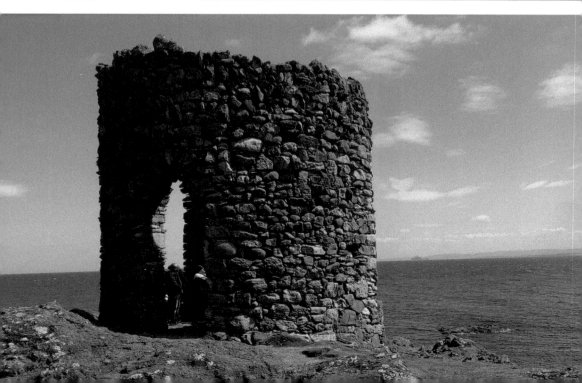

couldn't see the light on Isle of May or on Inchkeith. David Stevenson reported in 1909 that 'the light is a powerful one and is giving satisfaction to sailors'.

> Here is an old tower, roofless, and with the wind of heaven blowing through it – a derelict on the shore of time. It was built for the use of the ladies who lived long ago in the big house among the trees. Below the tower a large bathing pond was formed, which was filled by the incoming tide, the water being kept in the bath by the aid of sluices. A cave at the foot of the rock a few steps from the water, was used as a dressing room. It is said that when the ladies intended to bathe the bellman was sent through the village, warning the townspeople against straying in the vicinity of the tower between the hours of twelve and one.
>
> *East of Fife Record*, 4 January 1907

The Lady's Tower was built in the 1770s as a summerhouse for Janet Fall, Lady Anstruther. It seems that she enjoyed a swim in the sea and sent a bellringer around Elie to warn the local people to keep away, to protect her modesty. It was in ruins by 1855.

17. The Fife Coastal Path

The Fife Coastal Path was created in 2002 and runs 116 miles from Kincardine to Newburgh. The path along the stunning coastline takes in numerous places of historic interest, picturesque towns and villages, and award-winning beaches. There is also the opportunity to spot a diversity of wildlife.

Fife Coastal Path sign.

Fife Coastal Path – Crail to Anstruther.

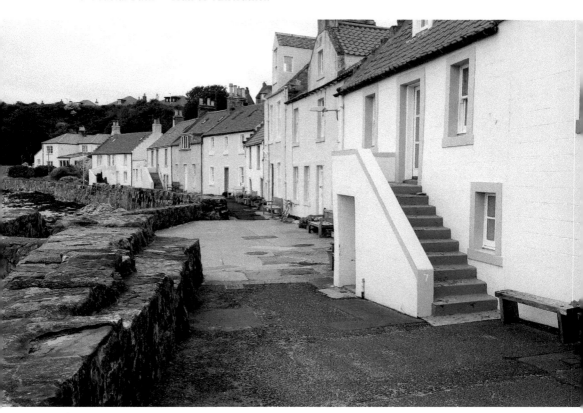

Fife Coastal Path at Pittenweem.

The complete long-distance walk is estimated to take eight to ten days; however, for the less energetic it can be completed in stages. The 4-mile section of the path between Anstruther and Crail, which was voted the best walk in Scotland in 2020, is one of the highlights of the route.

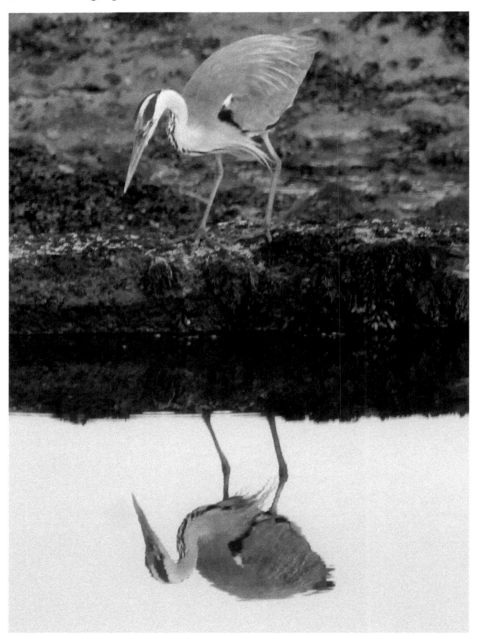

Heron on Fife Coastal Path.

18. The Chain Walk

The Chain Walk runs for 0.5 km between Kincraig Point and Earlsferry, to the west of Elie. It is not so much of a walk, but a clamber and climb along the cliff face supported by steel chains attached to the rock. The chains were first installed in 1929 and were replaced in 2010. It is an exhilarating experience and provides a close-up look at the geology of the area. The approach to the Earlsferry start of the walk is along a path through the golf course and along a beautiful stretch of sandy beach.

Above:
Approach to the
Chain Walk.

Right: Sign on
the Chain Walk.

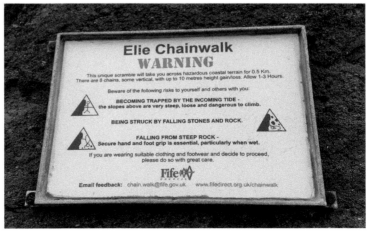

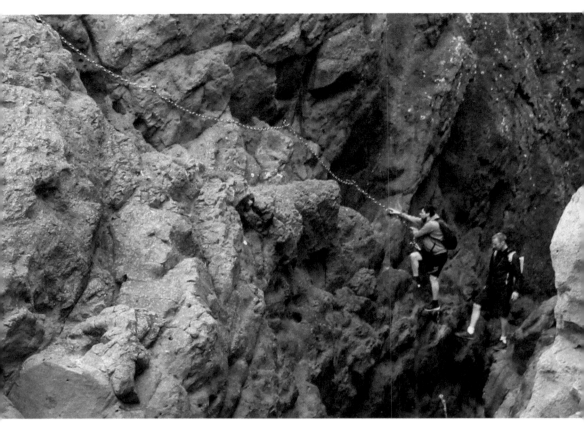

On the Chain Walk.

The Chain Walk can be undertaken as part of the Fife Coastal Path. However, there is an alternative, less precarious, route along the cliffs above, which can be followed by the less adventurous. It is essential that the walk is only undertaken at low tide and a couple of hours allowed to complete the route.

19. St Monans Parish Church

Once known as Inverin or Inverie, St Monans (or St Monance) takes its name from the legendary Saint Monan. Natives of St Monans are known locally by the colourful sobriquet 'Simminancers'. St Monans Parish Church is one of the finest medieval churches in Scotland. It is dramatically situated on a clifftop to the west of the village and right on the shoreline – it is the closest church to the sea in Scotland. The roots of the church date back to the ninth century when a shrine was built to Saint

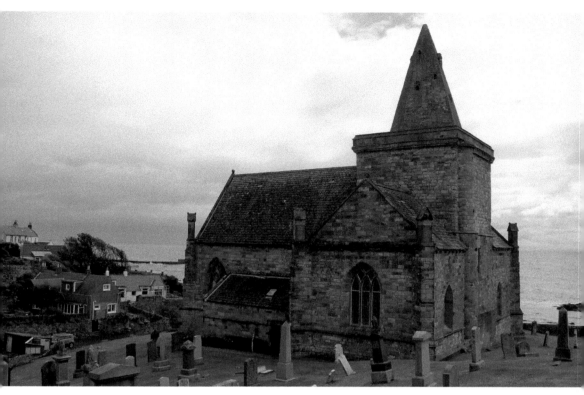

St Monans Parish Church.

Monan – possibly to mark the site of relics of the saint. The church was endowed by David II (1329–71) in the mid-fourteenth century. Legend has it that King David was wounded by two arrows at a battle in 1346, and one of the arrows could not be removed until he made a pilgrimage to the shrine of St Monan, when it miraculously fell from the wound. The church was badly damaged in a naval attack by the English in 1544. The church bell at one time was hung from a tree in the graveyard but was regularly removed during the fishing season for fear of frightening away the fish.

20. St Monans, Windmill and Salt Pans

The salt pans at St Monans were established by Sir John Anstruther and the Newark Coal Company between 1772 and 1774. The salt panning process required enormous quantities of coal. Horse-drawn wagons running on wooden rails linked the local coal mines with

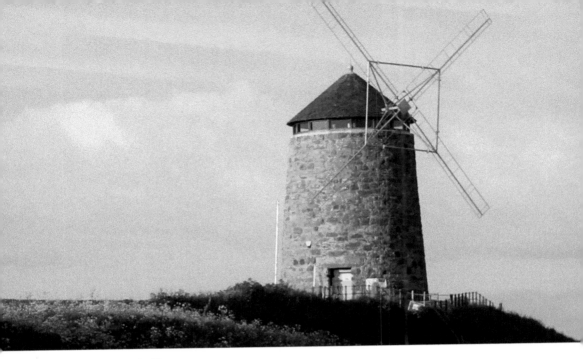

St Monans Windmill.

the salt works, and with Pittenweem. Salt water was pumped by a wind-powered engine into a shallow iron pan, a coal fire was lit beneath it and the brine boiled to produce salt. Each boiling cycle took twenty-four hours and when operating at full capacity, the nine pan houses required around 10,000 gallons of water per day. The windmill, which was used to pump seawater from a reservoir on the foreshore for distribution to the salt pans, is a distinctive local landmark. The salt pans ceased production in 1823.

21. The Zig Zag Pier, St Monans

Fishing has been the main industry in St Monans for centuries and the motto of the town is Mare Vivimus – 'We Live by the Sea.' The original jetty at St Monans is recorded as early as 1590 and lay close to the position of the current central pier. A west pier was built by 1858 and the Alexandra Pier in the 1860s. The harbour was extensively rebuilt in the 1880s and deepened in 1902–5. In 1900 there were over 100 fishing vessels and over 400 fishermen at St Monans and at times there were so many boats in the harbour that it was possible to walk from one side of the harbour to the other using their decks. The fishing industry declined after the Second World War and today few craft fish from the harbour.

The Zig Zag Pier is a unique feature of the harbour at St Monans. Known locally as The Blocks, it serves as a breakwater and was designed by Robert Stevenson. Located at the furthest seaward side of the harbour, the Zig Zag Pier is a photographic gem and there is frequently a queue of camera-wielding individuals waiting to climb the ladder on the harbour wall to catch a snap of it.

The Zig Zag Pier.

22. Newark Castle

'Here ladies bricht were aften seen, Here valiant warriors trod; But a' are gane! The guid, the great, and naething noo remains, But ruin sittin' on thy wa's, And crumblin' doun the stanes!'

The striking ruins of Newark Castle, also known as the Castle of St Monans, stand in an outstanding location perched on a clifftop just outside of St Monans.

Newark Castle.

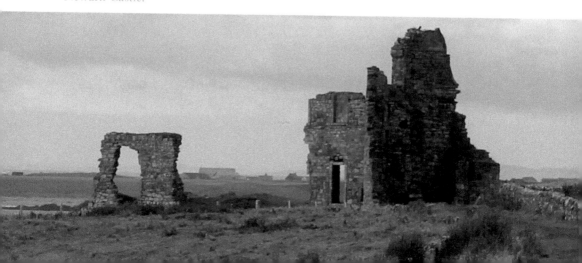

In the mid-thirteenth century, Sir Alan Durward built a castle on the site to take advantage of its defensive location and Alexander III spent part of his childhood at the castle, as guests of the Durwards. The castle was extended and improved by the Sandilands family in the fifteenth century and David Leslie, a General in the Scottish Covenanter Army, in the seventeenth century. Much of the castle has been lost to coastal erosion over the centuries. Sir Robert Lorimer produced an unexecuted plan for the restoration of the castle for Sir William Burrell, the Glasgow shipping magnate, in the late nineteenth century.

23. Pittenweem, St Fillan's Cave, Cove Wynd

Pittenweem, the place of the cave, takes its name from St Fillan's Cave on the steep Cove Wynd leading from the High Street to the harbour. The cave, formed naturally by erosion, is particularly associated with the eighth-century Saint Fillan, who is said to have lived for a time as a hermit in the cave. With the Reformation, worship of saints was discouraged, and the cave was put to

St Fillan's Cave.

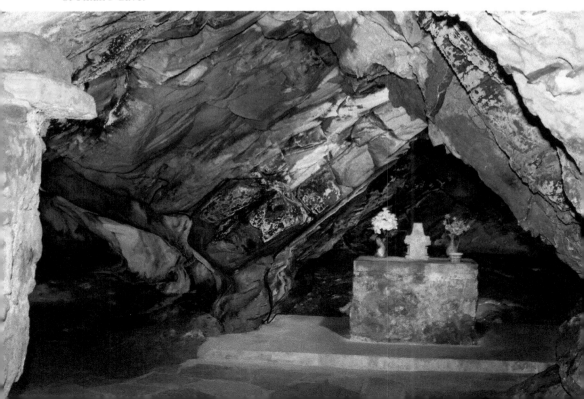

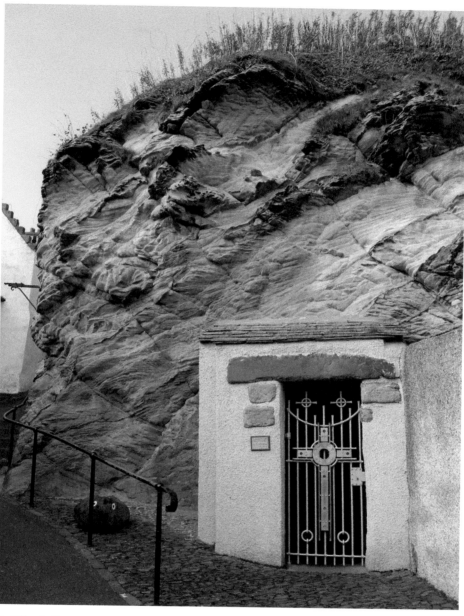

St Fillan's Cave.

various uses – it was used as a prison, for concealing smugglers' contraband, as a storeroom for local fishermen and as a rubbish tip. It was rediscovered in the early twentieth century, apparently when a horse fell down a hole, was reconsecrated for religious use in 1935 and fitted out as an atmospheric small chapel dedicated to Saint Fillan in 2000.

24. Anstruther Fisheries Museum, St Ayles, Harbourhead, Anstruther

Anstruther is the largest of the East Neuk villages and has a long association with fishing. The town was originally two separate communities, Anstruther Easter and Anstruther Wester, which developed on opposite sides of the Dreel Burn. In the nineteenth and early twentieth centuries it was the main herring port on the Forth – in 1840, there was a fleet of one hundred fishing boats and whaling from the town also began around this time. A new east pier, which was built in the 1860s, was damaged by storms in 1870 and after further storm loss it was finished in concrete in 1873, making it the largest fish harbour in Fife. After a record catch in 1936, the herring shoals mysteriously declined in the Forth. The industry effectively disappeared by 1947 and Anstruther's importance as a working harbour rapidly deteriorated.

In September 1965, Anstruther's Lord Provost, John Armour, launched an appeal for £13,500 to convert the derelict St Ayle's Chapel, at the eastern end of the harbour, into Britain's first fisheries museum. Hew Lorimer of Kellie Castle, East

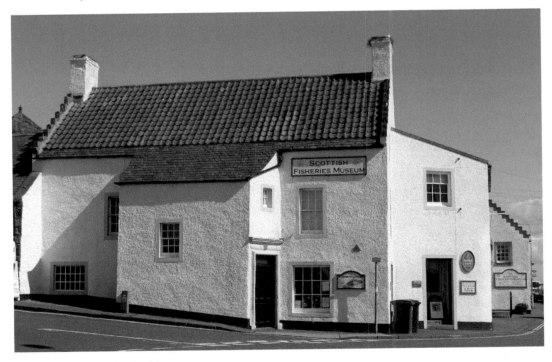

Anstruther Fisheries Museum.

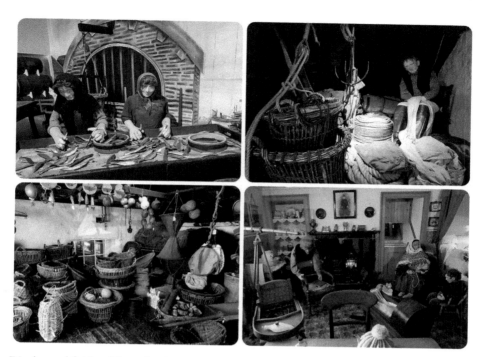

Displays of fishing life at the Anstruther Fisheries Museum.

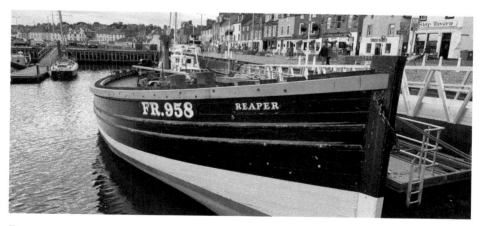

Reaper.

Fife representative of the National Trust for Scotland, noted that a whole section of our national life was in danger of passing into oblivion unless the museum was established. Lorimer along with Tom Laurie, a local builder, were the driving force behind the venture.

The buildings consisted of a seventeenth-century house, a range of two-storey sheds and a sixteenth-century building which was believed to have been the Abbot

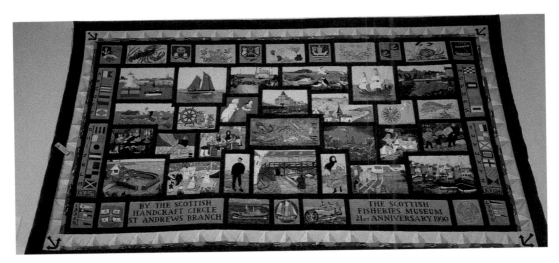

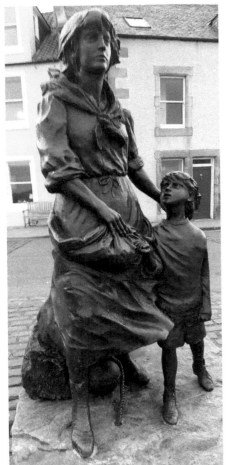

Above: Maritime life wall hanging at the Anstruther Fisheries Museum.

Left: Memorial at Pittenweem.

of Balemerino's lodging when he visited the monastery on the Isle of May. The buildings formed a ring around a courtyard which was entered through an arched gateway. The National Trust for Scotland had purchased the buildings in 1964 and sold them to Anstruther Town Council for £1,800. In 1968, they were handed over to the Scottish Fisheries Museum Trust.

It was proposed that the museum should contain a collection of pictures and models of ships of every type that have operated from the North Sea ports – Fifies, Scaffies, Zulus, Baldies, steam drifters and trawlers. Other exhibits would show the many methods of catching fish, fishing gear of the past and traditional dress. The annual running costs of the museum were estimated at £1,000, which it was hoped would be met by income from visitors. The museum was opened in July 1969 and within the first few weeks welcomed over 2,000 visitors. The display space has expanded over the years around the cobbled courtyard.

The museum has been awarded various accolades: a Civic Trust Award in 1971 for its imaginative use of an eighteenth-century building, the Museum of the Year Award in 1976, and the Scottish Tourist Board Oscar for the best visitor centre in 1982. In 1986, the museum featured in a Grampian television documentary, *Treasures in Store*.

Fishing has played a significant role in the social and economic history of Fife and the museum, located in a beautifully restored whitewashed building overlooking the harbour, provides a unique record of Scotland's fishing trade and the way of life of the fisherfolk.

The extensive and varied range of exhibits includes fishing boats, fishing gear and an early fisherman's cottage. Pride of place is the fully restored 70-foot wooden-built herring drifter *Reaper*, which has a berth in the harbour opposite the museum. Another major attraction is the wall hanging which depicts aspects of maritime life: Robinson Crusoe, Crail Harbour, smugglers, and air-sea rescue. There is also a poignant Memorial Chapel to Scottish fishermen lost at sea. The stained-glass window in the chapel was made by a local volunteer from glass collected on the beach.

The life-sized bronze statue of a woman and child looking out to sea at Pittenweem commemorates many lives lost at sea around the East Neuk. It was unveiled in September 2019 and is inscribed: 'The memorial is dedicated to the people who make their living from the sea and to those who have lost their lives in doing so.'

25. Stepping Stones, Anstruther

Stepping stones across the little stream/Sure they must lead into the land of dream/ Gently, one and two and three/Stop and sway you steadily/Four and five and six and seven/Now you're gazing into Heaven.

Dora Anderson, 1924

Stepping stones are a significant feature in Japanese garden design. They provide a precarious footing which results in a slowing down, time to pause, to look around and become more engaged with the surroundings.

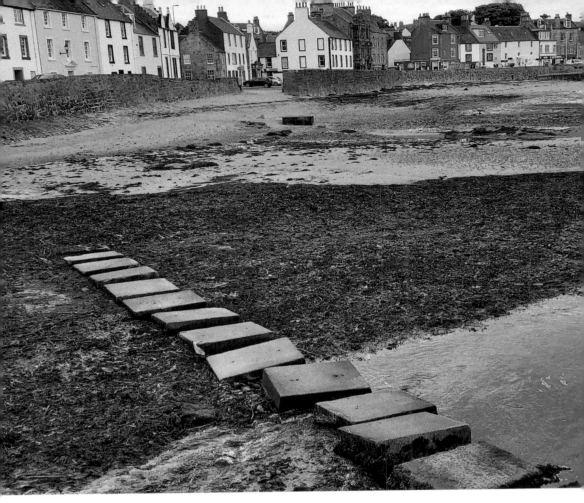

Stepping Stones, Anstruther.

At low tide, the large oblong stepping stones over the Dreel Burn, at Anstruther (locally known as 'the Steppies'), provide a convenient shortcut between the Esplanade and Castle Street. They also allow for a fresh perspective on the broad sweep of Shore Street and the Anstruther Wester Parish Church.

26. Cellardyke Harbour

Though Cellardyke is redolent with the odour of tar, bark, and fish, the prevailing sea-breezes are refreshing, and an air of homely comfort and thriving industry pervades the place.

Guide to the East Neuk of Fife, D. Hay Fleming, 1886

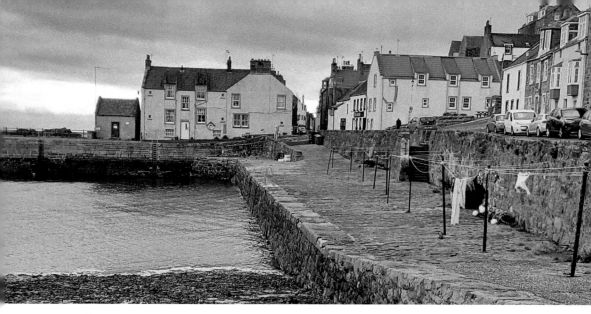

Cellardyke Harbour.

Cellardyke was known as Lower Kilrenny until the sixteenth century. It was also known as Sillerdyke, Silverdicks and the evocative Skynfischtoun. Sillerdyke is said to be a reference to the silvery reflection of the sun from fish scales on nets drying on the dykes around the harbour, and Cellardyke from cellars used to store the fish. The harbour is known as Skinfast-haven.

There was a harbour and thriving fishing industry at Cellardyke for centuries. John Beaton of Kilrenny, the local laird, provided a safe anchorage and a pier in 1579. The town was made a Burgh of Regality in 1578, which granted the rights to hold a market. A market cross was erected and a coat of arms adopted – a crewed fishing boat with a hook dangling in the water. The Latin motto of the town, *Semper Tibi Pendiat Hamus*, translates as 'May a Hook Always Hang for You'. In the mid-nineteenth century Cellardyke was a thriving place with more than fifty boat owners and skippers.

Further improvements were made to the harbour between 1829 and 1831; however, significant repairs were required after a storm in 1898. The introduction of larger fishing boats and the opening of a railway station at Anstruther in 1863 resulted in the extension of the facilities at Anstruther to form the Union Harbour and the winding down of fishing at Cellardyke. The washing lines on the harbour side add to the picturesque charm of Cellardyke.

27. The Caves of Caiplie

In the far distant past they (the Caves of Caiplie) have been wrought out by the sea in the half-detached rock. Some of the cavities go quite through the rock. The largest cave has a lofty roof, and measures fully forty feet from its mouth to

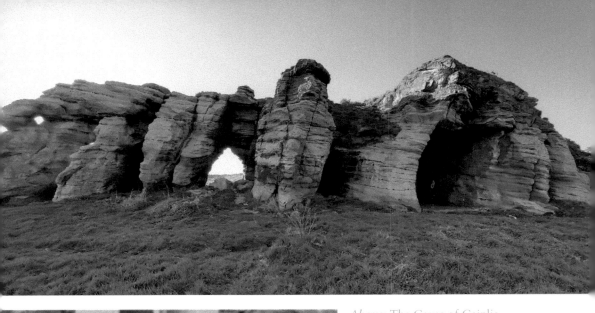

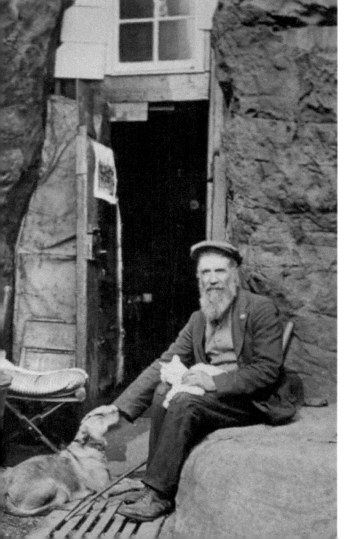

Above: The Caves of Caiplie.

Left: Jimmy Gilligan, the Caiplie Hermit, in 1915.

the pointed recess at the inner end. It bears the unmistakable marks of having been artificially enlarged, although it is still irregular in shape. This has been called the Chapel Cave. On the north wall a small niche has been cut out of the rock, and many crosses are around it. There is also a Greek cross within a surrounding line, and many Latin ones. The numerous crosses vary much in size. The modern ones can easily be distinguished from the truly ancient. A century ago, there was a small chamber in the rock above, partly artificial and arched over, which was reached by steps cut in the rock, beginning near the mouth of the passage, or cave, into which the door of the Chapel Cave opened. In the inner end of the upper chamber there was a bench cut in the rock, which may have been used as a bed. This cell had in later times been fitted up as a pigeon house. In 1841, in front of the east cave, and about two feet below the surface, a human skeleton was discovered, as if thrown head-foremost into a hole; and a little nearer to the sea, another four skeletons were found, as if they had been regularly buried. In front of the 'Chapel' and adjoining caves, and within the latter, were found a great many bones of cattle, boars' tusks, pieces of deers' horns, etc., mixed with earth and stones. There can be no doubt that Caiplie is 'Caplawchy', the place to which Adrian and his company came; and it may be safely inferred that these caves are some of the 'steddis' in which a portion of them chose to dwell. In the Chapel Cave and upper chamber, we may picture to ourselves the establishment of one of these early heralds of the Gospel to the rude tribes of Alba. Not only was the upper chamber turned into a pigeon-house; but, before the end of last century, the Chapel Cave was converted into a barn, and was large enough to admit two threshers at a time. The caves have since been used for sheltering cattle. In the New Statistical Account, it is said that 'there is no tradition regarding them, except that there is a communication below ground between them and the house of Barnsmuir, situated nearly half-a-mile from the shore, where it is said that a piper was heard playing beneath the hearth-stone of the kitchen' – but these days of delusion have passed away.

Guide to the East Neuk of Fife, D. Hay Fleming, 1886

The Caves of Caiplie, known locally as 'The Coves', are a landmark feature on the coastal path between Crail and Anstruther. There are a number of incised crosses in the caves which have been linked to early Christianity in Scotland and St Adrian, who is said to have preached at the caves in the ninth century. They have also been used as a doocot and for sheltering livestock.

One of the caves was the abode of a homeless man called Jimmy Gilligan, who was known as the 'Caiplie Hermit'. Jimmy had taken up residence at Caiplie in 1909 and is reported to have lived there until 1939. He was born in Aberdeen in 1859 and joined the 92nd Gordon Highlanders as a young man. He served in the Afghan War of 1878–80 and in the Boer War, where he suffered a head wound at the Battle of Majuba Hill on 27 February 1881. On 11 November 1882, he was dishonorably discharged from the army for assaulting a corporal. His health was not good due to his war wound and he was admitted to hospital in Edinburgh. In 1909 he was homeless, and his wanderings brought him to Fife, where he discovered the caves at Caiplie. After taking shelter in one of the caves, he resolved to make it his home,

which he equipped with a stove, a bed, a table and other home comforts. It seems that he was a popular character and welcomed visitors into his cave home.

Jimmy lived in the cave until the outbreak of the Second World War and then he disappeared. Recent research has shown that he died at the age of eighty-one in a Leith hospital on 20 January 1940. His last known address was an Edinburgh Salvation Army hostel, indicating that he was still homeless.

28. Crail Harbour

Crail's royal charter, which gave the town special trading rights, dates from 1178 and it is one of the most ancient Royal Burghs in Scotland. There has been a haven for boats at Crail since the earliest days of the town and at one time it was the most important port in the East Neuk. It was originally designed for small trading or fishing vessels, so had a narrow harbour entrance. The curved breakwater dates from the sixteenth century and the straight west pier was added in 1826–28 to the design of Robert Stevenson. The harbour is surrounded by buildings dating back to the seventeenth century with white-harled walls, crow-stepped gables and red-pantiled roofs. Crail is without doubt the most picturesque harbour in the East Neuk. The harbour has even been recreated in miniature at Legoland in Denmark.

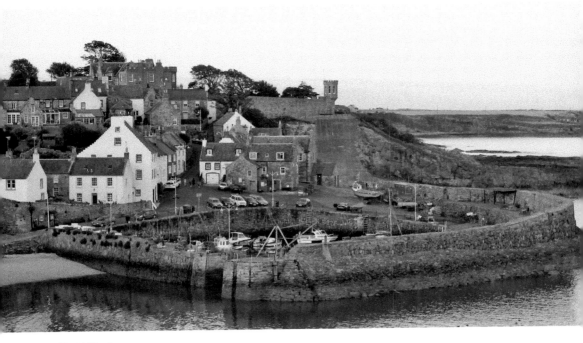

Crail Harbour.

29. Crail Tolbooth

Crail Tolbooth was the governmental centre of the town and housed the jail. Its distinctive roof dates from the late sixteenth century, although the bell tower and clock were later additions in 1776. The bell, which dates from 1520, was cast in Rotterdam and reflects the town's links with the Netherlands. The weathervane in the shape of a fish is a reminder of the Crail capon, a smoked haddock, a delicacy which the town produced in great quantities and that made Crail famous. The adjacent town hall dates from 1814 and replaced an earlier townhouse of 1602.

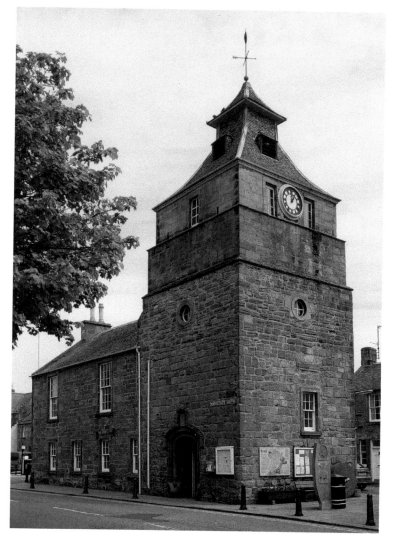

Crail Tolbooth.

30. Crail Pottery, 75 Nethergate, Crail

Crail Pottery, at the heart of Crail on the historic Nethergate, is set around a picturesque walled courtyard in which is displayed a colourful array of the potters' work. The pottery was established in 1965 by Stephen and Carol Grieve after they had restored a couple of derelict buildings, which they purchased for £250. Today it is run as a co-operative by their daughter Sarah, son Ben and extended family members.

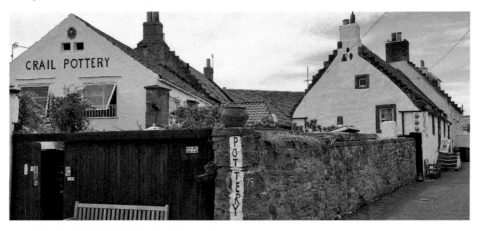

Above: Crail Pottery.

Left: Sarah Mills at work at Crail Pottery.

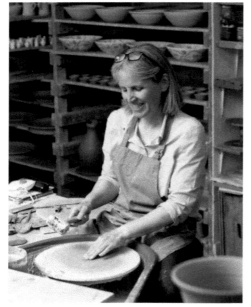

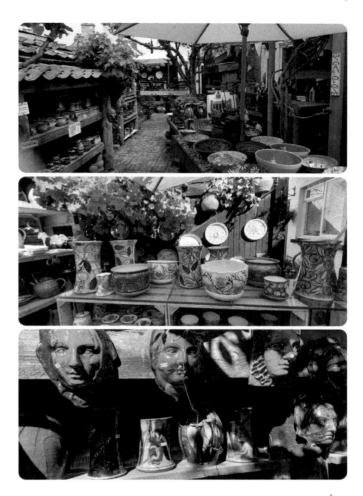

Crail Pottery
courtyard.

Crail Pottery produces a diverse range of stoneware, earthenware and ceramics, from jugs and mugs to teapots and planters. Every piece is handmade and decorated with designs exclusive to Crail Pottery, ensuring that each has its own inimitable character. A visit to Crail Pottery to peruse the showroom and courtyard displays and see the potters at work is one of the highlights of a visit to Crail.

31. The Priory Doocot, Crail

The Priory Doocot in Crail dates from 1550, is 7 metres high and is fitted with around 700 nesting boxes. In 2017, it was restored by the Crail Preservation Society and was formally opened by the Lord Lyon, King of Arms in May 2019.

Dovecotes (doocots in Scotland) are prominent features in the rural landscape of Fife. A considerable number have survived for centuries because of their substantial construction.

The earliest forms of dovecotes were those converted from natural caves or cut into rock – 'doo caves'. The Romans kept pigeons in a columbarium or peristeron and are recorded as being 'mad with the love of pigeons, building towers for them on the tops of their roofs'. The earliest surviving Scottish doocots date from the sixteenth century with possibly the oldest, dated 1576, being at Mertoun House, St Boswell. They are particularly numerous in Fife because estates in the area were relatively small and consisted of mainly rich arable land producing fine agricultural crops which provided an excellent source of food for the pigeons. Doocots were also the legal right of abbeys, castles, and monasteries.

Pigeons provided a valuable source of year-round fresh meat and eggs, adding variety to meals in the winter months. The pigeon droppings, which built up in the doocots, made an excellent fertiliser, and were used in the production of gunpowder and in the processes of leather tanning and cloth dyeing. There was also a prevalent belief that pigeons had medicinal properties, and they were used in various forms as a cure-all for everything from the plague to baldness.

There have been laws concerning doocots since 1424, when an Act relating to destroyers of dow-houses was passed. In 1503, under James IV, an Act directed all lairds and lords to lay out deer parks, orchards, stanks for fish, cunningaries (rabbit warrens), and to erect 'dowcots' as a benefit to the community. However, pigeons could have a significant effect on surrounding crops, and by 1617 another statute was necessary on account of 'the frequent building of doucottis by all manner of persounes in all the parts of the realm.' This restricted the privilege of building doocots to owners of land which produced ten chalders or 160 bolls (1.25 cwt) of grain within 2 miles of the site of the doocot to attempt to ensure the pigeons fed on the landowners' crops rather than their neighbours.

Early surviving Scottish doocots are of two main types. The first purpose-built doocots, dating from the sixteenth century, as with the Priory Doocot, are beehive shaped, circular in section and tapering towards the top with a flat domed roof. The other early style, which superseded the beehive design in the late sixteenth century, is the rectangular lectern type, which appears to be peculiar to Scotland. These have a distinctive sloping mono-pitched roof often with crow-stepped gables that

The Priory Doocot, Crail.

provided a perch for the pigeons and are normally divided into separate chambers. The roofs usually face south to give the birds a sunny surface to rest on, while sheltering them from northerly winds. The more sophisticated construction of the lectern type doocots allowed for greater ornamentation that became more elaborate as time went on.

Doocots continued to be built well into the eighteenth century and later examples have a variety of forms. From the mid-eighteenth century, they were frequently constructed as ornamental features of the policies of country houses, acting as eye-catchers within a designed landscape.

The need for doocots gradually died out at the start of the nineteenth century as their function in providing an extra source of fresh food in wintertime became obsolete with the introduction of new farming methods that allowed for the feeding of cattle in the winter. The pigeon's habit of indiscriminate feeding was also seen as a source of social injustice (one of the minor causes of the French Revolution is said to have been the destruction of peasants' crops by pigeons owned by the French aristocracy). It is recorded that there were at least 360 doocots in Fife during the eighteenth century, and it is little wonder that farmers began to complain.

32. Cambo Gardens

We next entered the grounds of Sir David Erskine, Bart of Cambo. Having found Mr Falconer, the gardener, at his house, which is at least a mile from the garden, we proceeded on in that direction. The grounds have a gentle declivity towards the sea; and in the park there are several undulations, and a few detached trees and groups, &c, with the carriage drive winding gracefully among them. Entering the garden by the north entrance, we at once perceived it to be a natural garden, that is, the surface of the ground is in its natural form, with a small brook running through the centre, over which are several neat cast-iron bridges. In the hot houses were fair crops of grapes; but in the black grapes there was a great deficiency of colouring, notwithstanding Mr. Falconer's giving strong fire and sun heat. The flower garden is small but neat and contains some fine specimens of rare plants. The kitchen garden produces all sorts of fruit and vegetables.

The Gardener's Magazine, 1834

The Cambo Estate has been in the ownership of the Erskine family for nearly 300 years. Thomas Erskine (1745–1828), 9th Earl of Kellie, implemented extensive land drainage and established sensitively designed model farms with a range of ornamental eye-catchers including a doocot, dairy and mausoleum. The serpentine access drive runs parallel to the Cambo Burn and the banks of the burn form a woodland walk to the beach at Cambo Ness. The 2.5-acre walled garden, which is a particular highlight of a visit to Cambo, forms part of the original designed landscape and features meandering paths around bold colourful flower beds, ornamental bridges over the Cambo Burn and a small summer house. The gardens

Above: Cambo walled garden.

Below: Cambo House.

at Cambo are now particularly celebrated for the outstanding collection of over 350 varieties of snowdrops and other spring-flowering bulbs. The Snowdrop Festival runs between February and early March. Cambo House is a substantial mansion house which dates from 1879 to 1881. It was built for Sir Thomas Erskine following the loss of the original house by a fire in July 1878. The house is not accessible to the public as part of entry to the gardens.

33. The Dutch Village, Craigtoun Park

Craigtoun Park was formally declared open by Mr G. Bruce, the former Lord Provost of St Andrews, on 30 May 1950 as 'a place of recreation for the people of Fife for all time'. The mansion house, which was being converted into a maternity home, and estate had been sold to the county council by Captain JP Younger. It was noted as being the county's first public park, the 'beauties of which were beyond description'. The county council had acquired the park, which was then known as Mount Vernon, in 1947 at 'very generous terms' from Captain Younger.

At the time the park included Dutch, Japanese and Italian gardens which had been constructed by the Younger family. Additional facilities included a rose garden, a wishing well, an orchard, tennis courts and a putting green. The two lakes were linked by a waterfall and a subterranean grotto. The Dutch Village on an island on the larger lake is a highlight of a visit to the park.

The Dutch Village, Craigtoun Park.

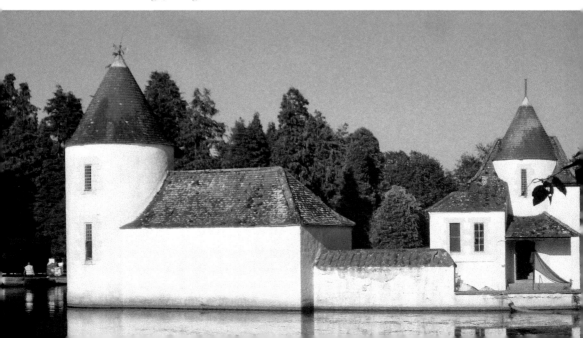

34. The Botanic Garden, St Andrews

The Botanic Garden at St Andrews was first established by the university in 1889 and is the third oldest botanic garden in Scotland. Originally located in a walled garden at St Mary's College, the present 7-hectare (18.5-acre) site, at Bassaguard on the banks of the Kinness Burn, was developed between 1962 and 1970 on former agricultural land to the south-west of the town centre. The garden features over 8,000 plant species and 300 trees, laid out amidst ponds, waterfalls, rock and peat gardens, herbaceous borders and extensive glasshouses. It has been described as 'a hidden gem among the gardens of Scotland' and is a tranquil retreat from the bustle of the town.

35. The Golfers' Bridge, St Andrews

Never shall I forget my first night in St Andrews. A dangerous small boy was swinging a new driver at an invisible ball on the hotel mat. Three men leaning on the visitors' book were arguing about a certain mashie. A girl in the lounge was shrilly defending her conduct on the home green. At the next table to me in the dining-room sat a man in plus fours who cheered his solitude by practising approach shots with his soupspoon. When the spoon, fresh from a bunker of oxtail, was no longer playable, he did a little gentle putting with a bread pill and a fork.

In Search of Scotland, H. V. Morton, 1929

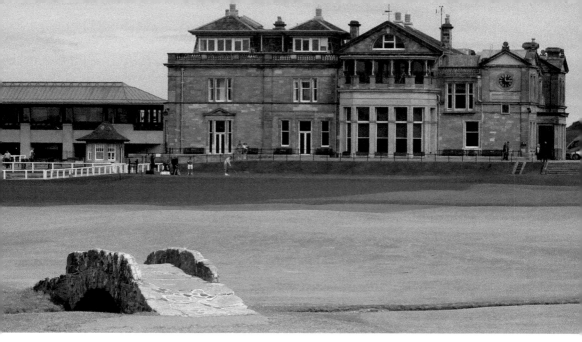

The Swilcan Bridge, Royal & Ancient and Golf Museum, St Andrews.

St Andrews is a delight; an old grey town of ancient houses and monastic ruins; full of men in plus fours and women with golf bags on their tweed shoulders; of undergraduates in splendid scarlet gowns; of happy meetings in cake-shops; of wayside gossip; of fine windows full of silk nightdresses, Fair Isle jumpers, brogues, golf clubs, golf bags, and, strange to say, one or two bookshops, presumably for the use of the Oxford of Scotland.

In Search of Scotland, H. V. Morton, 1929

The First or Bridge Hole: Sacred to hope and promise is the spot./ To Philp's and to the Union Parlour near,/To every Golfer, every caddie dear/Where we strike off – oh, ne'er to be forgot,/Although in lands most distant we sojourn.

Extract from first verse of the poem *The Nine Holes of the Links of St Andrews*

St Andrews is celebrated as the 'Home of Golf', and the Golfers' Bridge, over the Swilcan (Swilken) Burn on the Old Course, is an internationally recognised iconic symbol of the game – there is even a full-scale replica of the bridge on display at the World of Golf Hall of Fame in St Augustine, Florida. It is a single segmental arch with low rubble parapets and dates from the seventeenth or eighteenth century. On 7 September 1810 it was recorded in the Minute Book of the Royal and Ancient that 'the Secretary was authorised to employ a tradesman to repair the Golfers' Bridge at the Links, which is at present almost impassable, and to pay the expense thereof'.

The humble little bridge is a touchstone for golfers and there are few landmarks in the world of golf that are better known. An internet search for the Swilcan Bridge reveals hundreds of images of golf legends, Hollywood celebrities and keen amateurs posing for a photo-shoot on the bridge. Tom Watson kissed it during the 2010 British Open and Sam Snead did a tap dance across it in 2000. If you search hard enough, you can even find images of a certain blonde-haired former US President wearing

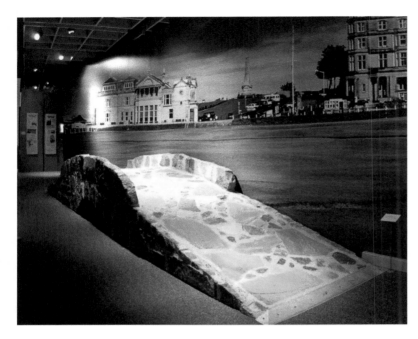

Replica of the Swilcan Bridge at the World of Golf Hall of Fame in St Augustine, Florida.

the rather unusual golf attire of a business suit, shirt, tie, and overcoat posing for a photo on the bridge.

The R&A World Golf Museum, which is located in a modern building adjoining the clubhouse of the Royal and Ancient, contains a comprehensive collection of golfing memorabilia, which documents the history of the game from the sixteenth century by a series of interactive displays. It was originally established, in 1990, as the British Golf Museum and, after extensive renovations, opened as the R&A World Golf Museum in 2021.

'I was invited to the Royal and Ancient. The windows of the club provide an unsurpassed view of players setting out over the Old Course and of the fine, green sweep of the links, bounded by sand-dunes and the white horses of St Andrews Bay' (*In Search of Scotland*, H. V. Morton, 1929).

The classically designed Royal and Ancient Golf Club House, with its balcony overlooking the Links, dates from 1854 and was extended over the years to accommodate the evolving requirements of the club.

The earliest record of golf at St Andrews is the St Andrews Links Charter of 1552, which details the public ownership of the links and the right of the townspeople to use the ground for grazing sheep, drying clothes, and other domestic chores, and playing golf and other games. In 1691, the Regent of St Andrews University described the town as 'the metropolis of golfing'. By 1766, a Society of St Andrews Golfers had been established in the town and, in 1834, King William IV granted the right for the society to adopt the title the Royal and Ancient Golf Club of St Andrews.

In its early days, the course would have been fairly rough. In 1864, 'Old' Tom Morris (1821–1908) was appointed as Keeper of the Green. His innovations

transformed the Old Course and were a blueprint for the form of courses in the UK and worldwide.

The demand for golf at St Andrews resulted in additional courses being established: the New Course (1895) by Old Tom Morris, the Jubilee Course (1897), and the Eden Course (1914). The Old Course only became known as such after these additional courses were laid out.

36. St Andrews Castle

The Castle was founded in 1200, by Bishop Rodger, and served the triple purpose of Episcopal Palace, State Prison, and Fortress; in short, the Bastille of Scotland. It was taken by Edward of England in 1298, who held it for several years, when it was re-taken by the Scots. It was again taken by the English but surrendered after Bannockburn. Bishop Lamberton repaired it, but Edward Baliol, assisted by Edward III of England, again seized it about 1332, and held it for three years. Sir Andrew Murray, Regent of the Kingdom, for David II, recovered it and demolished it, to prevent its again falling into the hands of the English. In this ruinous condition it lay until about the end of the fourteenth century, when it was re-built by Bishop Trail. In 1526, it was pillaged by the Douglasses. In 1546, Cardinal David Beaton was murdered in it, and his murderers, and others, held it in possession for a year, and only surrendered it after sustaining a lengthened siege, by sea and land, from both Scotch and French Troops, and Fleet: it was then for the second time demolished.

St Andrews Castle.

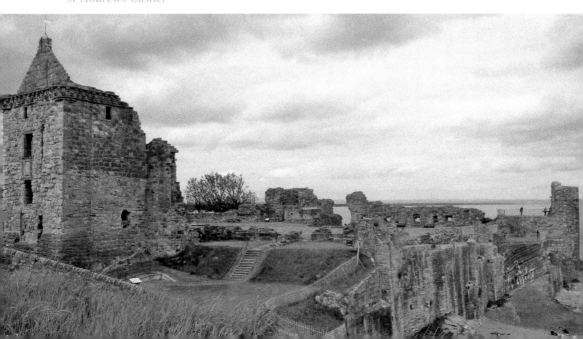

The successor of Cardinal Beaton – Archbishop Hamilton, re-built it, and it is the ruins of his structure that are now to be seen.

The Intelligible Guide and Manual for St Andrews, James Howie, 1859

The ruins of St Andrews Castle occupy a picturesque setting on a rocky headland above the Castle Sands beach. The castle was originally built in the twelfth century as an administrative base and residence for the Catholic clergy at a time when St Andrews was the religious centre of Scotland. The building has had a turbulent history. Razed and rebuilt a number of times during the Scottish Wars of Independence, the ruins that remain today mainly date from a reconstruction in around 1400. During the Scottish Reformation, it was captured by the Protestant lairds. A prolonged siege of the castle ensued. In 1546, the besiegers started a siege tunnel under the castle, which was met underground by a tunnel excavated by the holders of the castle resulting in an underground battle between the two groups (the tunnels were rediscovered in 1879 and are open to the public). The Protestant defenders of the castle were finally overpowered by a massive bombardment by a French fleet. John Knox was captured by the French and spent time as a galley slave on a French ship. With the completion of the Reformation, in 1560, Catholic mass was banned. The castle lost its principal purpose and fell into ruin over the following decades, which was exacerbated by storm damage. By the mid-seventeenth century stones from the castle were being used to repair the harbour. The bottle dungeon, with its narrow entrance, is a grisly reminder of the castle's often violent history.

37. The Byre Theatre, St Andrews

The inaugural performance in St Andrews' first licensed theatre was held last night by St Andrews Play Club, whose members have created the club from a former byre. Last night's opening was the culmination of a dream which has inspired the club of enterprising young drama enthusiasts. The club was formed four years ago to study drama and produce plays which were out of the ordinary. They rented premises in Abbey Street from the Town Council and proceeded to convert what was originally a byre, and later served as a potato store and a garage, into a theatre. Practically all the work in connection with its transformation has been carried out by the members themselves. It has included the erection of a stage and proscenium, the installation of a lighting system, repainting the building and converting a loft into dressing rooms and a store for scenery. Miss Alice Lumsden, LRAM (Eloc.), who had travelled from Aberdeen for the occasion, gave a lecture-demonstration on voice production. The programme concluded with the presentation of the one act play 'The Foreigner,' by AB Paterson.

The Courier and Advertiser, 24 April 1937

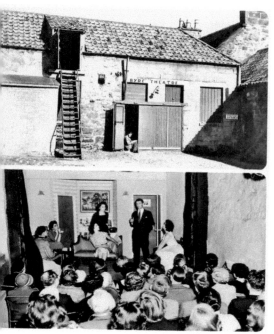

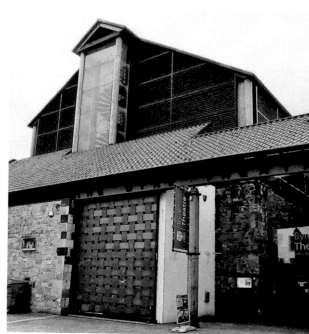

Above left: Early days at the Byre Theatre.

Above right: The Byre Theatre.

The Byre Theatre has been a vibrant part of the cultural life of St Andrews from its inception in a converted cowshed by a group of local theatre enthusiasts in the 1930s. In 1970, the original building was replaced, and the current modern theatre was opened by Sir Sean Connery in 2001. However, financial difficulties in early 2013 resulted in its closure. In October 2014, the theatre reopened under the management of the University of St Andrews. This has allowed the Byre to continue its long heritage of diverse creative and artistic activities.

38. West Port, St Andrews

St Andrews was once enclosed by a burgh wall for defence and to control the movement of merchandise. Several gateways (ports) formed impressive monumental entrances to the town. Few examples of city ports survive in Scotland, and St Andrews is fortunate in having two still extant: the Sea Yett and the West Port. The West Port (So'gait port), at the west end of South Street, is one of the finest

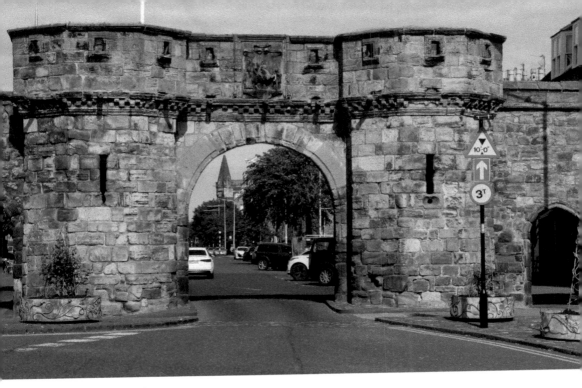

West Port, St Andrews.

examples in Scotland. The contract between David Russell, Dean of Guild, and Thomas Robertson, mason for its construction, is dated 18 May 1589 and specifies that the port should be constructed of fine ashlar work in the style of the Netherbow Port in Edinburgh. The gateway was restored and altered in 1843, when the two side arches and two plaques decorated with the city coat of arms and depicting David I on horseback were added.

39. St Mary's College, South Street, St Andrews

The University of St Andrews, which was established in 1412, is the oldest university in Scotland and the third oldest in the English-speaking world after Oxford and Cambridge. The university, like Oxford and Cambridge, is based on a college system; St Salvator's, St Leonard's and St Mary's are the three main groups of college buildings.

Gates in an archway at the east end of South Street in St Andrews lead into the tranquillity of the ancient quadrangle of St Mary's College. The gates are inscribed with the biblical motto *in principio Erat Verbum* ('in the beginning was the Word').

The first college on the site was dedicated to St John and was established in 1419. In 1538, St Mary's College (New College) was founded by Archbishop James Beaton. The oldest buildings, including the Founder's House, are on the west side of the quad and date from the sixteenth century. The college is an internationally renowned centre for the study of Divinity.

During 1645–46, the Scottish Parliament met in a building on the north side of the quad, which is still known as Parliament Hall. James Gregory (1638–75), the eminent mathematician and astronomer, who was the first Regius Professor of Mathematics at St Andrews (1668–74), had a laboratory on the upper floor of this building. Gregory made significant contributions to advances in mathematics, astronomy and physics. In 1672, he calculated a meridian line passing through St Andrews, which is commemorated by a brass strip and plaque on South Street outside the college.

The massive holm oak which dominates the quadrangle was planted in the mid-eighteenth century. The hawthorn bush at the entrance to the Founder's House is said to have been planted by Mary, Queen of Scots, in the 1560s. The college originally occupied buildings to the south of the quad, but these were demolished following a fire in 1727 and the sixteenth-century gateway is all that remains of these buildings. A statue of Bishop Wardlaw stands in front of the gateway.

St Mary's College entrance gates.

Above: Founder's House and Holm Oak, St Mary's College.

Below: Remains of gateway and statue of Bishop Wardlaw, St Mary's College.

40. Blackfriars Chapel, South Street, St Andrews

The first object worthy of the stranger's attention, on his entrance to the city by the West Port is the ruins of the Monastery of the Dominican or Black Friars, immediately in front of the Madras College. This Monastery was founded and adorned by Wishart, Bishop of St. Andrews, in 1274, being forty-four years after the Dominican order of friars came into Scotland. These friars received the appellation of Black, from their wearing a black cross upon a white cloak. They were a mendicant order, and were also named patres predicatores or preaching friars, because their peculiar office was to declaim against the encroachments of heresy. They were free from Episcopal control and had liberty to confess and administer the Sacraments to all those who applied to them. The history of this Monastery, from its foundation to the era of the Reformation, is almost unknown, its dignity being eclipsed by the all-engrossing splendour of the far-famed Cathedral. The grounds on which the Dominican Monastery stood, became the property of Lord Seaton after the Reformation, having been made over to him by John Grierson, provincial of the Order in Scotland. It often changed owners, until in modern times it became the property of Dr Young, Dean of Winchester, who granted it to the town for the site of a Grammar School. Ultimately it was purchased by the late Dr Bell, for the site of the Madras College. Previous to the purchase of the property by Dr Bell, the ruins of the Monastery, unheeded and uncared for, were allowed to moulder into almost complete decay; but since it has been considerably repaired and surrounded with an iron railing, so that the remaining transept is now a venerable ornament to the modern buildings around it. Lately it received further repair; and while care was taken to preserve its ancient architectural beauty, it presents a more pleasant aspect to the eye of the beholder.

Fletcher's Guide to St Andrews, 1853

Blackfriars Chapel.

The remains of the north transept of Blackfriars Chapel are a prominent feature on South Street and an important remnant of St Andrews' ecclesiastical history. The chapel was built in 1525 and is all that remains of the Dominican Friary in St Andrews, which was first established in the thirteenth century. In 1599, much of the friary was destroyed and the friars expelled by Protestant reformers.

41. The Cathedral of St Andrew and St Rule's Tower, St Andrews

St Andrews, if not the most ancient City of the Kingdom, dates at least from a very early period. If 370 A.D. be the correct date of its foundation, there can be little wonder that its early history is involved in obscurity and doubt, and intermingled with Monkish fable. The story thus runs – A Greek Monk, named Regulus, living in the city of Patras in Achaia, was warned, by a vision, to visit the shrine of St Andrew, and, with certain relics therefrom,

St Andrews Cathedral and St Rule's Tower.

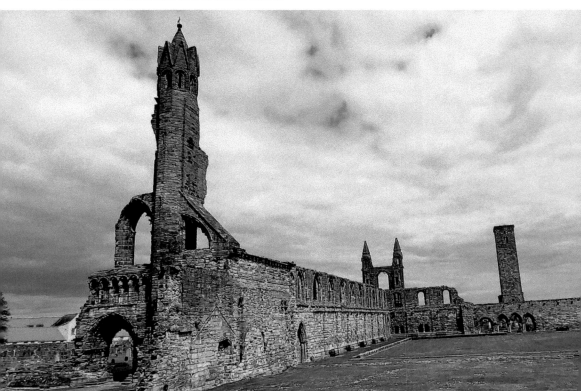

to sail to an island in the remotest extremity of the Western World. He hesitated to obey, but a repetition of the vision compelled obedience, and accordingly he set out on the voyage, accompanied by seventeen Monks and three Nuns, and taking with him the arm-bone, three fingers, and three toes of the Apostle. After two years' sailing, they were shipwrecked in the bay of St Andrews, the whole crew narrowly escaping with their lives, and saving only the sacred relics of the Apostle. They took refuge in a cave on the sea margin, long known as St Regulus' Cave, but now popularly known as Lady Buchan's Cave, a little to the east ward of the Castle ruins. Hergust, king of the Picts, hearing at his capital of Abernethy of the arrival of the strangers, soon paid them a visit, the result of which was, that the simplicity of their manners and doctrine at once made converts of his people from Paganism to Christianity, and he built for them the square tower and chapel which yet bear the name of St Regulus – that structure is thus almost 1500 years old, probably the oldest building in Scotland.

The Intelligible Guide and Manual for St Andrews, James Howie, 1859

The above is the legendary account of the arrival of the relics of Saint Andrew, the patron saint of Scotland, in St Andrews, although it is more likely that they came to St Andrews in the eighth century, when a religious community was first established in the town.

St Rule's (St Regulus') Church was built in the early part of the twelfth century to house the relics of Saint Andrew. The most prominent remains of the church are the 33-metre (108-foot) high tower. A climb up the 156 steps of the tower is rewarded by a spectacular view of the town and surrounding countryside.

St Andrews became the ecclesiastical capital of Scotland and the cathedral, which was completed in 1318, was the largest church in Scotland. The town of St Andrews was founded in 1140 as an episcopal burgh and developed with its principal streets focused on the cathedral. The wide main streets were planned to accommodate the vast number of pilgrims that visited the town. In 1559, during the Reformation, the cathedral was attacked, and its present ruinous condition is due to it being used as a quarry for other building projects in the town.

42. St Athernase Church, Leuchars

Half-way between St Andrews and Newport the motorist who knows a Norman church when he sees one jams on his brakes as though he has suddenly met a great cow on the road. Leuchars Church! The sight of that astonishing apse, like a Norman knight in chainmail sitting a war-horse among gravestones, just takes the breath out of the body. This unique apse which time has bequeathed

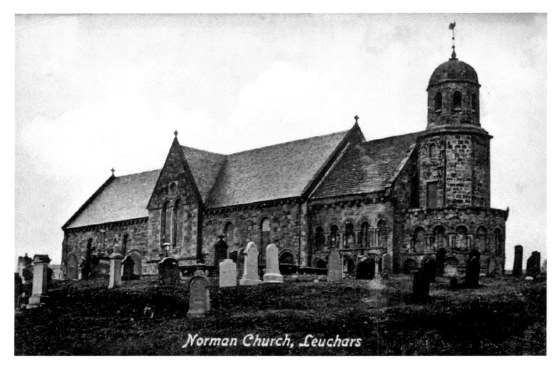

Norman Church, Leuchars

St Athernase Church, Leuchars.

to a village church in Fife is the most beautiful relic of the period I have seen in Scotland.

In Search of Scotland, H. V. Morton, 1929

The church of Leuchars is an object of great interest to all who are in the least degree acquainted with the subject of ecclesiastical architecture. The eastern portion of the building is beyond doubt of high antiquity and is one of the few specimens existing in Scotland of the Norman style of architecture. The building appears to have been erected at three distinct periods. The eastern portion, together with the semi-circular apse at its extremity, constituted the chancel of the ancient church, and is of the greatest antiquity; the portion to the west of the chancel constituted the nave, and was of subsequent formation, while the third or most westerly division is of comparatively modern construction, having been built, it is probable, about the time of the Reformation.

The Kirk and the Manse, Robert William Fraser, 1866

St Athernase Church stands on an elevated site in Leuchars. It was consecrated and dedicated in 1244, but records show that it existed in 1187 when the Earl of Mar and Baron of Leuchars gifted the church to the Priory of St Andrews. The chancel and apse at the east end of the building date from the twelfth century and represent some of the finest surviving examples of Romanesque architecture in Scotland. The nave was extensively altered in the mid-nineteenth century.

43. Dunino Church and Dunino Den

Dunino is a small village on the B9131 between St Andrews and Anstruther. There has been a church at Dunino since 1240 and the present parish church dates from 1826. The churchyard includes the remains of a Bronze Age stone circle and Dunino Den, in the woods behind the church, is an ancient pre-Christian site which has been used for rituals for thousands of years. The Den is a mysterious and atmospheric

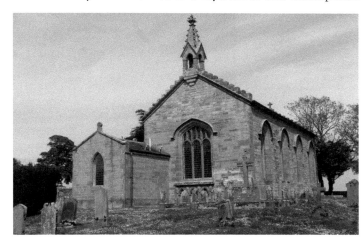

Right: Dunino Church.

Below: In Dunino Den.

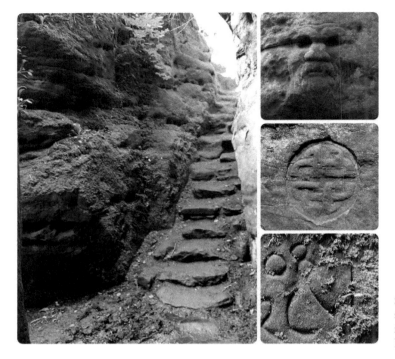

Steps and
stone
inscriptions,
Dunino Den.

place. Two crags, known as the Altar Stone and Pulpit Rock, overlook a clearing in
the woods, which can be reached by a set of narrow steps. An ancient circular well
and footprint have been carved into the Altar Stone and various symbols, including
a Celtic cross and knotwork, have been inscribed into the cliff faces. The range of
offerings (ribbons, beads, candles and coins) that have been left in the Den by visitors
indicates that many believe that the site has special powers.

44. The Secret Bunker

The Secret Bunker, which lies a few miles south-west of Dunino on the St Andrews to
Anstruther Road, is one of Scotland's more unusual visitor attractions. Built in 1952,
at the height of the Cold War, it was intended to function as a base for the regional
government in the event of an escalating nuclear threat.

The entrance to the bunker is disguised by a building designed to look like a
traditional farmhouse, which does not seem out of place in the surrounding countryside.
Access to the bunker is along a 300-foot-long tunnel which slopes down to 100 feet
below ground level. The bunker is encased in a 15-foot-thick layer of concrete and
sealed by blast-proof steel doors. It seems that the construction of the bunker and other
similar sites in the 1950s resulted in a nationwide shortage of cement.

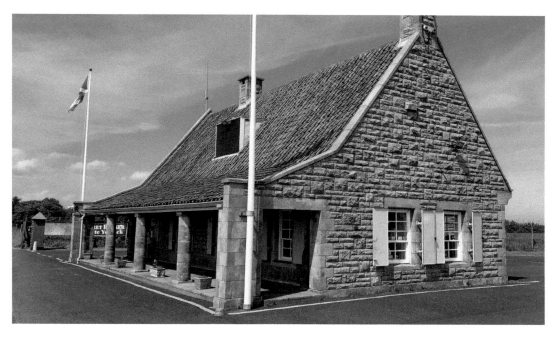

The Secret Bunker.

The bunker was fitted out to accommodate 300 people and is a massive construction covering around 40,000 square feet. The bunker had its own water and electric supply, and a plant room designed to filter incoming air to remove radioactive particles or bacteria from germ warfare. Features of a visit include the Royal Observer Corps room, the dormitory sleeping quarters, the chapel and the BBC radio station. The Secret Bunker opened to the public in April 1994, shortly after it was decommissioned, and its presence removed from the Official Secrets Act.

45. Kellie Castle

There are records of a castle at Kellie from the mid-twelfth century and parts of the present structure date back to the fourteenth century. The castle was developed by the Oliphant family over the period of their tenure from 1360 to 1613, when Sir Thomas Erskine took over the estate. Erskine had saved the life of King James VI and the King stayed at Kellie in 1617, shortly before Erskine was appointed Earl of Kellie. The 5th Earl was a Jacobite and is said to have evaded capture after Culloden by hiding in a hollow tree in the garden for the entire summer of 1746. The castle was abandoned and fell into disrepair in the mid-nineteenth century, and, by 1860,

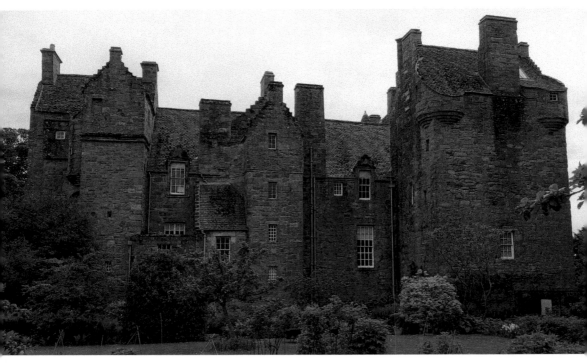

Kellie Castle.

some of the grand rooms were in use as a barn. In 1878, Kellie Castle was leased to the Lorimer family and Sir Robert Lorimer, the eminent architect, spent much of his childhood at the castle. Hew Lorimer, the renowned sculptor, took over the lease in 1937 and later purchased the estate. In 1970, Kellie Castle was purchased for the nation by the National Trust for Scotland.

46. Fife Folk Museum, High Street, Ceres

The Fife Folk Museum first opened in 1968 and has expanded over the years. The museum occupies the former seventeenth-century Ceres tolbooth (the Weigh House), adjacent early nineteenth-century weavers' cottages and a modern extension on the opposite side of the High Street. The historic use of the tolbooth as the local prison is reflected in the motto, 'God Bless the Just', above the front door and the jougs attached to the wall beside the front door. The jougs (from jugum a yoke) consist

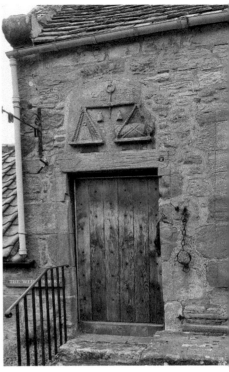

Above left: Fife Folk Museum.

Above right: Former tolbooth doorway, Ceres.

Below: The Bishop's Bridge.

The Provost of Ceres.

of an iron collar in two halves fastened by a clasp; offenders found guilty of some minor breach of the law – such as drunkenness, immorality, Sabbath breaking or blasphemy – had to undergo the humiliation of being fastened to the wall with their necks in the jougs. The carving of a weigh beam above the front door also reflects the use of the building as the place where grain was weighed on market days. The museum displays an extensive array of fascinating items relating to the social, domestic and working lives of the people in Fife.

The museum is approached over the picturesque Bishop's Bridge over the Ceres (Craighall) Burn. The bridge dates from the seventeenth century and is named for Archbishop Sharp. Sharp (1618–79) was Archbishop of St Andrews from 1661 to 1679. He was a controversial figure and his support for Episcopalianism cost him his life. It is said that he crossed the bridge on 3 May 1679, the day that he was murdered by Covenanters. The Bridge forms part of the Fife Pilgrims Way which runs for 70 miles from Culross to St Andrews and retraces the historic pilgrim's route through Fife to the cathedral at St Andrews.

The little Toby Jug-like statue opposite the Ceres Inn is known as The Provost of Ceres and is said to represent Thomas Buchanan (1520–99), a local minister and the last Provost of Ceres.

47. Falkland Palace

The chief object of attraction in Falkland is the Royal Palace. This interesting edifice was originally a stronghold belonging to Macduff, Earl of Fife, which, on the forfeiture of Murdoch, Duke of Albany, in 1424, was attached to the crown and became a hunting lodge. The present building, which is but one of three sides which formerly existed, was erected by James V, who died in it. The other two sides were accidentally destroyed by fire in the reign of Charles II. It was the favourite residence of James VI, probably on account of that monarch's attachment to hunting, for which the adjacent forest afforded

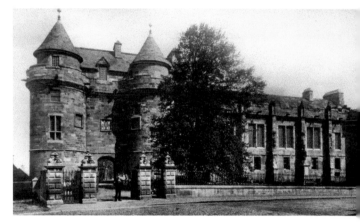

Right and below: Falkland Palace.

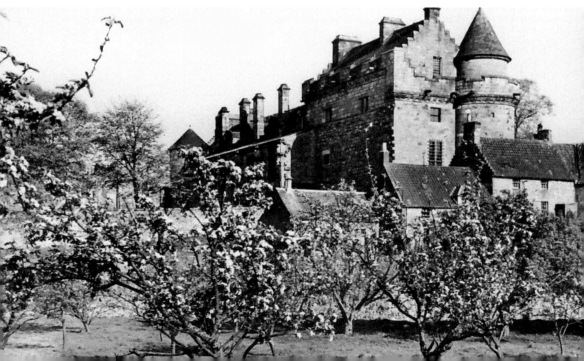

excellent opportunities. The last royal personage who occupied it was Charles II, who resided in it for some days, both previous to and after his being crowned at Scone. Until the erection of the present Manse, it was possessed by the minister of the Parish. Being then left tenantless it fell into utter decay; the roof was demolished, the floors destroyed, and almost everything but the walls gave way. This was owing to the neglect of the keeper, who held his office in connection with a neighbouring property. At length the estate was purchased by Mr Tyndall Bruce, one of Her Majesty's printers for Scotland, who resolved to rescue the Palace from the fate which seemed to threaten it. He commenced in 1823, a course of operations which may rather be called a restoration than a repair. He renewed the roofs and the floors, caused the windows which had been built up to be re-opened, and the crevices in the walls to be plastered up with cement, fitted up the interior as an elegant modern mansion, and finally decorated the environs with the appropriate charms of a flower garden. Before the whole of these elaborate and expensive operations had been completed, he was removed by death, but the work has been perfected according to his appointment by his heiress and her husband; and it is now a pleasure, instead of a mortification, to contemplate this remarkable monument of the taste and magnificence of one of our most beloved monarchs.

Westwood's Parochial Directory for the Counties of
Fife and Kinross, 1862

It is known that for some time prior to the eleventh century, the County was, in a great measure, either the property or under the potent jurisdiction of a line of Thanes, or Earls, of the name of M'Duff, who, from the middle of the eleventh century to the forfeiture of the family in 1424, were among the most influential of the Scottish Peerage. The chief residences of the Earls of Fife were at Cupar and Falkland. From various concurring evidences in history, we learn that the Peninsula of Fife was originally almost an entire forest full of swamps, as indeed was nearly all the rest of Scotland. While in the condition of a forest, it was the haunt of wild beasts, and especially boars of a large size, and it is understood that such creatures, as well as the larger animals of the chase, were not extirpated until after the reign of James V, who, like his predecessors, made Fife the scene of his hunting expeditions, while residing at the royal residence of Falkland.

Westwood's Parochial Directory for the Counties of
Fife and Kinross, 1862

Falkland Palace has its origins in a twelfth-century hunting lodge which was developed as a more substantial castle in the thirteenth century by the Earls of Fife. The surrounding countryside was rich in game, and it was a popular country retreat of the Stewart monarchs. In 1451, the present palace was begun by James II and further improvements created a beautiful Renaissance royal palace for the House of Stewart. It was the scene of several significant historical events.

In 1654, the palace was badly damaged by a fire during its occupation by Cromwell's troops and by the 1800s it was in a derelict condition. In 1887, the Marquis of Bute purchased the Keepership of the Palace and commenced a major restoration project.

The Royal Tennis Court in the grounds of the palace dates from 1539 to 1541 when the palace was remodelled for King James V and is the oldest tennis court in the world which is still in use. Mary, Queen of Scots is said to have been a particular enthusiast for the game on her frequent visits to Falkland.

Highlights of a visit to the palace include the Chapel Royal and the extensive gardens, which were restored in the 1940s.

Since 1952, the National Trust for Scotland has been responsible for the care of the palace and gardens.

48. Lochore Meadows Country Park

Located around a beautiful loch, the Lochore Meadows Country Park is a major destination for outdoor leisure activities. The park, which opened in 1978, was reclaimed from former large-scale mine workings. Reminders of the area's mining heritage include the winding tower of the Lochore Colliery (Mary Pit) and the National Coal Board locomotive, which was used at the Frances Colliery at Dysart. The remains of the fourteenth-century Lochore Castle stand at the entrance to the country park. The castle was originally located on an island, Inchgall, on Lochore.

The Mary Pit, Lochore.

Above: Lochore.

Left: Winding tower
and locomotive, Loch
Ore.

49. Balgonie Castle

One of the principal objects of antiquarian interest in the Parish is Balgonie Castle, situated a little to the west of the village of Milton, on the banks of the Leven, about thirty-six feet above the level of the stream. The buildings are obviously of different ages, but the castle was lately in repair, and formed one of the residences of the Earls of Leven within the last 75 years. The great tower is the most ancient portion and was probably built in the fourteenth or fifteenth century. It is eighty feet high, with battlements at the top, and is forty-five feet in length by thirty-six in breadth over the walls. The walls of the two lower stories, which are arched with stone, are eight feet thick. The remaining buildings form an extensive quadrangle, in closing a court.

Westwood's Parochial Directory for the Counties of Fife and Kinross, 1862

Balgonie Castle is an early fifteenth-century courtyard castle. The Sibbald family were the original holders of Balgonie, and it has been altered and enlarged over the centuries by several owners, resulting in an interesting eclectic mix of different styles and periods. By the mid-nineteenth century it was a roofless ruin and remained in a derelict condition until an ongoing restoration scheme started in the 1970s. It now operates as a wedding venue and has been used in the filming of the *Outlander* series.

Balgonie Castle.

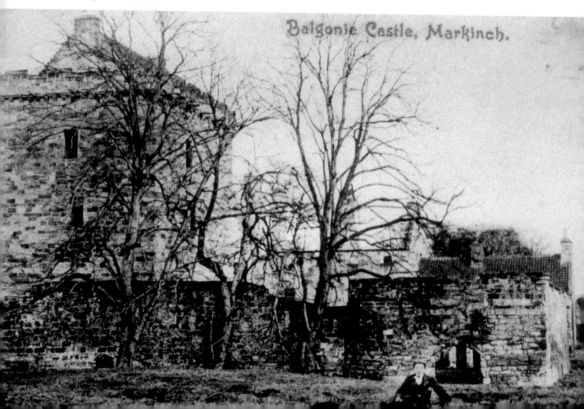

Balgonie Castle, Markinch.

50. The Isle of May

Prolific May, whose ever-burning lamp
Through dangerous seas, between approaching coasts,
Amid hidden scares, unseen, and broken rocks,
In pitch of night, directs the doubtful path
Of fearless mariner.

The extreme length of the island is only a mile and a sixth, its greatest breadth is a quarter of a mile, and it contains little more than 140 acres. Standing on the top of the precipitous cliffs, it is delightful to watch the fowls circling high o'er head, nestling on narrow ledges of the rock, or diving in the water one hundred feet below. There are two places where passengers can be landed in clear weather, but which are respectively unapproachable when the wind is in the east or west. At a third point the mails are sometimes landed, and this leads me to say that no visitor should go without taking newspapers for the keepers. They are so shut out from the rest of the world that these are highly acceptable.
Guide to the East Neuk of Fife, D. Hay Fleming, 1886

The Isle of May has been a designated National Nature Reserve since 1956 and is owned and managed by NatureScot. At the peak of the breeding season around 200,000 seabirds nest on the high cliffs of the island. The colony of puffins, which breed between April and early August, is a particular attraction for visitors. The island is also an important breeding site for grey seals.

 The Isle of May also has a long cultural heritage. It was the site of one of Scotland's earliest Christian communities reflected in the remains of the priory dedicated to St Ethernan (Adrian), which date from the twelfth century.

Below left: Lighthouse, Isle of May.

Below right: Puffins, Isle of May.

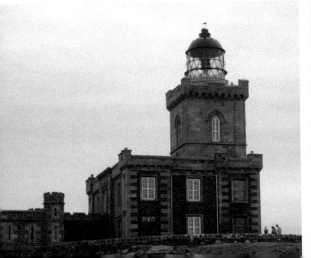
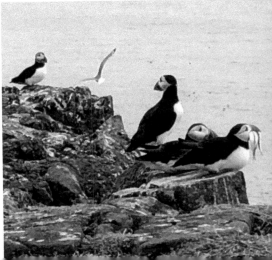

The navigation beacon that was constructed on the island in 1636 was the first in Scotland. It was privately owned, required three keepers to run it and consumed hundreds of tons of coal every year, which was paid for by a tax (originally an impost of 2s Scots on the ton of all native ships and vessels and 4s Scots on strangers, for each voyage) on passing ships when they made landfall. In 1814, the Commissioners of Northern Lighthouses purchased the island from the then owner, the Duke of Portland, for £60,000. The new Isle of May lighthouse was designed by Robert Stevenson and opened on 1 September 1816. To make the entrance of the Firth safer, another lighthouse, the Low Light, was opened on the island in April 1844. It is now disused and functions as a birdwatching observatory

The island has been the site of two tragic accidents.

In January 1791, the lighthouse keeper, his wife, and five children, were suffocated. One child, who was found sucking the breast of her dead mother, was saved; and the two assistant keepers, though senseless, were got out alive. The ashes, which had been allowed to accumulate for more than ten years, reached up to the window of the keeper's room; and having been set on fire by live coals falling from the lighthouse, and the wind blowing the smoke into the windows, and the door below being shut, the result was inevitable. The two men who escaped declared that a sulphurous steam was observed to issue from the heap of cinders for several weeks before the fatal night on which it burst into flames, and therefore it was supposed by some that there had been a fermentation among the ashes. On the 1st of July 1837, a boat from Cellardyke, containing fifty-eight passengers, besides a crew of seven, was swamped at the landing, and thirteen persons, chiefly young women, were drowned.

Guide to the East Neuk of Fife, D. Hay Fleming, 1886

Ferry excursions to the island run from the harbour at Anstruther during the summer months.

High cliffs, Isle of May.

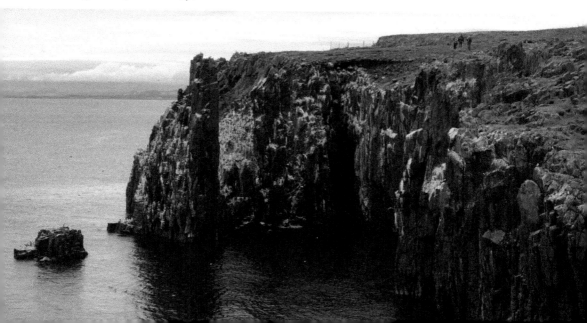

Acknowledgements

I would like to thank Sarah Mills of Crail Pottery, Andrew W. Johnson of the Fife Folk Museum, Linda Fitzpatrick of the Anstruther Fisheries Museum, Jess Munroe of the World Golf Hall of Fame, Steve Milne, and Kate and Jim Grant for help with images.

In the East Neuk of Fife by Norman Gillon.